Art Offic

80° BUSINESS FORMS, CHARTS, SAMPLI LEGAL DOCUMENTS & BUSINESS PL

BY CONSTANCE SMITH AND SUE VIDERS

TRITTE LES CANACIONES POR LA CONCENTRACION DE COMPANS D

CONTRACTOR SECTIONS OF ACCORD

Art Office

80° BUSINESS FORMS, CHARTS, SAMPLE LETTERS, LEGAL DOCUMENTS & BUSINESS PLANS FOR FINE ARTISTS

Art Office 80+ BUSINESS FORMS

by Constance Smith and Sue Viders Cover Illustration: Laura Ottina Davis Copyright © 1998 by ArtNetwork

Published by ArtNetwork, PO Box 1268, Penn Valley, CA 95946 530 470 0862 530 470 0256 Fax info@artmarketing.com http://www.artmarketing.com Can't locate us? Probably we've moved. For our new number send us e-mail, go to our internet site, or call 800·383·0677.

ArtNetwork was created in 1986 with the idea of teaching fine artists how to earn a living from their art creations. In addition to publishing art marketing books and newsletters, ArtNetwork has a myriad of mailing lists available. See the back of this book for details. Send a SASE or call for the most current brochure.

Publisher's Cataloging-in-Publication

Smith, Constance.

Art office: 80+ business forms for the fine artist / by Constance Smith and Sue Viders -- 1st ed. p. cm. Includes index. ISBN: 0-940899-27-2

1. Art--Marketing--Forms. 2. Art--Economic aspects. 3. Business--Forms I. Viders, Sue II. Title.

N8353.V54 1998

706.8'8

QB197-41365

All rights reserved. Copyright under Berne Copyright Convention, Universal Copyright convention, and PanAmerican Copyright Convention. No part of this book may be reproduced, stored in a retrieval system, or transmitted in any form, or by any means, electronic, mechanical, photocopying, recording or otherwise, without prior permission in writing from the publisher, except by a reviewer, who may quote brief passages in a review. NOTWITHSTANDING the foregoing, artists may reproduce any form in this book without charge for the limited purpose of use in their business.

DISCLAIMER: While the publisher and authors have made every reasonable attempt to obtain accurate information and verify same, occasional changes are inevitable, as well as other discrepancies. We assume no liability for errors or omissions.

Printed and bound in the United States of America

ABOUT THE AUTHORS

Sue Viders has been a practicing artist (BFA) and an art marketing consultant for over 30 years. She is the Director of the Art Education Division for Color Q Inc, a fine art printing company, and author of numerous articles and columns in *American Artist Magazine* and *Artist's Magazine*. Viders has authored numerous books, charts and audio tapes on art marketing. She is a seminar lecturer at national art and trade shows.

Constance Smith, owner and founder of ArtNetwork, has been assisting fine artists nationwide in their marketing needs for more than 13 years. Professional networking has made her familiar with all facets of the artworld. Previous to publishing marketing information in books and newsletters, she represented fine artists in the San Francisco Bay Area. Her latest book, *Art Marketing 101*, has been called "a must for all fine artists attempting to market their work in today's marketplace."

500日 100年 100日 日下午 100日本

INTRODUCTION

This book is designed to save the fine artist time and energy, as well as help avoid frustrations. It includes basic forms that a fine artist will need throughout his/her career. Using these forms will give your business a professional look, improve your impression on clients and, in turn, bring you increased sales and respectability. In some instances we have given you more than one choice of form. You can design your own forms based on our models.

All the 80+ forms and worksheets in this book are meant to be **photocopied** by you for your personal business use.

Many forms apply to your in-house organization needs. Some, however, are for your customer and have been designed to accommodate your own business name and logo. You can adhere a copy of your logo to the original form in this book and then photocopy.

We have divided the book into three major sections. Comments about each section and each form within each section are at the beginning of each chapter. If you don't understand how some of the forms can help you, you probably need to learn more about the business aspect of art. Review *Art Marketing 101* by Constance Smith.

Section I - Getting Started

This section includes general office forms to help you in maintenance, organization, book-keeping and legal aspects of your career.

Section II - Art

This section provides you with inventory forms to help you keep track of your artwork, where you've sent samples, whom you need to follow up with, etc. It also has forms that will assist you to know what market to target.

Section III - Marketing

This section presents calendars to help you plan your marketing throughout the years, sample letters, pricing sheets and invoices.

We suggest you keep your photocopied forms in a three-ring binder. Divide your binder into sections and/or chapters as we have done. Consider color coding your photocopies by section.

Running a fine art business and keeping it in order are much easier with a system. With this handy book of standardized forms at hand, you can take the worry out of daily record-keeping and routine tasks and put more time into keeping on top of your competition.

If you have a computer, take advantage of these forms on diskette. A Macintosh computer with PageMaker 5.0 or higher is required. An order form is on the back page of this book.

Happy photocopying!

Constance smith & sue Viders

TABLE OF CONTENTS

SECTION I GETTING STARTED

Chapter 1 Office	
Daily organizer	12
Daily planning schedule	
For the week of	
Weekly schedule	15
Twelve-month planning calendar	16
Memo	17
Fax cover sheet	
Chapter 2 Bookkeeping	
Income/expenses	20
Monthly income by source	21
Financial statement	
Entertainment/meal documentation	23
Daily mileage report	24
Travel documentation	25
Projected budget	26
Balance sheet	27
Check reconciliation form	28
Checklist for contracts	31
Sales agreement	32
Exhibition agreement	
Artist-gallery agreement	
Consignment schedule	
Artist-gallery consignment agreement	
Work-for-hire agreement	38
Model release	
Property release	40
Commission agreement	
Rental-lease agreement	
Artist-agent agreement	
Worksheets for Form VA	45
Form VA	47

SECTION II ART

Chapter 4 Inventory

Historical documentation of prints	52
Artwork out	53
Slide reference sheet	
Slides/photos/transparencies/portfolios out	
Competition record	56
Exhibitions/competitions	
Item request record	
Chapter 5 Customers	
Target market chart	60
Customer profile	
Customer/client record	
Phone-zone sheet	
Mailing list sign-up sheet	64
CECTION III	
SECTION III	
MARKETING	
MANKETHIG	
Chapter 6 Marketing plans	
Sample marketing plan	66
Marketing plan	67
Five-year goals	
Twelve-month goals	69
Project planner	70
Project progress chart	71
Monthly project status	72
Show planning calendar	
Twelve-month show planner	
Exhibit expense planner	
Publicity planning chart	
Checklist for a juried show	
Print planning calendar	78

C	hapter 7 Letters	
	Introduction letter	80
	Query to gallery	
	Application request	
	Sample issue request	
	Response to inquiry	
	Query to book publisher	
	Query to art publisher	86
	Query to magazine editor	
	Query to interior designer	
	Confirmation of sale	
	Confirmation of exhibition	
	Thank you for purchase	
	Press release	
C	hapter 8 Sales	
	Pricing worksheet for originals	94
	Pricing worksheet for prints	
	Certificate of title	
	Certificate of authenticity	97
	Bill of sale	98
	Provenance	
	Price list	100
	Index	101

SECTION I GETTING STARTED

CHAPTER 1 DAILY OFFICE FORMS

Daily organizer

This form is for daily planning. Keep these for IRS records as well as for your personal reference.

Daily planning schedule

This is an alternative form to the above. Always have a daily planner filled out for the next day. In this way, when you walk into your office, you will know precisely what your aims are for the day.

For the week of

Weekly planner and phone log.

Weekly schedule

This weekly overview will help you not miss any appointments with clients.

Twelve-month planning calendar

Keep track of bigger projects on this yearly planner. Add to it as the year progresses.

Memo

As this form is one that will leave your office, the blank space on the upper right side is available for your logo and address.

Fax cover sheet

This can be used as an introductory page for a multiple page fax, or as your entire fax, with a message hand-written directly on it. Space for your logo again.

DAILY ORGANIZER

Date		

TIME	PROJECT	APPOINTMENTS
7 AM		
8 AM		
9 AM		
10 ам		and All
11 AM		
NOON		
1 PM		19810.6970
2 РМ		160 C C C C C C C C C C C C C C C C C C C
3 PM		48.3V0Q
4 РМ		A STATE OF THE STA
5 PM		
6 РМ		
7 PM	A BEST OF SOLD BUT SHEET STORES	
8 рм		
9 РМ		

NOTES

	TO DO			PHONE CALLS	
1	ITEM	1	NAME	PHONE #	REASON
	* :				73
			3 F.	88	A A
	2				

DAILY PLANNING SCHEDULE 9 AM 3 PM 10 AM 4 PM 11 AM 5 PM NOON 6 PM 1 PM 7 PM 2 PM 8 PM **NOTES**

FOR THE WEEK OF

THINGS TO DO	PHONE LOG
	Name
	Phone
	Topic
	Name
	Phone
	Topic
	*
APPOINTMENTS	Name
	Phone
	Торіс
	Name
	Phone
SPECIAL ATTENTION	Topic
SPECIAL ATTENTION	
	NOTES
	100 Aug 100 Au
· · · · · · · · · · · · · · · · · · ·	

GOALS FOR	THE WEEK		GOALS	FROM LAST WEEK
Monday	✓ •	Tuesday	/	Wednesday
	D	,	D	
	0		C	
1	P		P	
	Н		l l	
	O N		0	
	E		6	
	•			
Thursday	✓ D	Friday	✓ D	Saturday/Sunda
	0		- c)
	P		F	
			F P	
	P			

TWELVE-MONTH PLANNING CALENDAR

JANUARY	FEBRUARY	MARCH
APRIL	MAY	JUNE
JULY	AUGUST	SEPTEMBER
OCTOBER	NOVEMBER	DECEMBER

16

MEMO Date То From Re

FAX COVER SHEET

Date	Number of pages (including cover)
ТО	FROM
Name	Name
Company	Company
Telephone	Telephone
Fax	Fax
1	NOTES/COMMENTS
	or incomplete, please call phone number above.

SECTION I GETTING STARTED

CHAPTER 2 BOOKKEEPING FORMS

Income/expenses

This is a simplified form of a 12-column ledger. A ledger could also be used (available at any office supply store). This tool is a must if you want to know what is happening financially on a monthly, quarterly and yearend basis.

Monthly income by source

This form helps you to analyze the year's income, providing you with valuable information for future planning. If, for example, you find prints bring you the most money, you will probably decide to expand your business in that direction.

Financial statement

This is yet another tool to help you study your income trends as well as where you might be overspending. This can be computed on a monthly or quarterly basis.

Entertainment/meal documentation

This is a mandatory record required by the IRS if you plan to take deductions in this category. Be sure to keep good records.

Daily mileage report

Another report required by the IRS. Keep a copy of this report in your car, filling in business miles and purpose as they occur. At the end of the year you will arrive at your percentage of business usage (versus personal usage) for your vehicle by taking total miles travelled for the year and dividing that by business miles travelled for the year. You are allowed to take that percentage of your actual receipts for auto expense.

Travel documentation

The IRS also requires travel documentation when you take a trip for business purposes. This form will also help you budget future travel expenses. Staple receipts to the back for easy reference.

Projected budget

Estimating future income and expenses enables you to see what activities have to be done to reach your aims. Revise this each guarter. File for future reference.

Balance sheet

Compile this annually to see where you stand financially. Banks require this form when you apply for a credit card or loan.

Check reconciliation form

This type of information is on the back of your bank statement. If you use the computer software program *Quicken*, you won't need to use this form.

INCOME/EXPENSES

Month	of	,

INCOME

Date	Name/Payor	Amount	Acct #
	PARTY OF SHIPPING O	7	
			,
92 (1) 12 V pt	esse.		XI C
			- sour mark drones
5,5,55,1230		1 1 1 1 1 1 1 1 1 1 1 1 1 1 1 1 1 1 1	
		1 111111	
	TOTALS	X 1	est and the state of

EXPENSES

Date	Check #	Name/Payee	Amount	Acct #
164				
38. 1			3	
		30.1		
		- F		28.
*				
	*. 1			P
				na gorgans
		TOTALS		

MONTHLY INCOME BY SOURCE

	Rentals	Gallery	Reps	Patrons	Shows	Prints	Other
January							
February							
March					2.7		
April		.0					
May)	
June			0.00				
July					250		
August							
September		Book		5	0.1001		
October					2		
November							
December							
TOTALS				WG (F)			

FINANCIAL STATEMENT

Month/quarter of

《李文文》	INCOME
Rentals	
Gallery	
Reps	
Patrons	
Shows	
Prints	
Other	
Total income	
THE RAPE	EXPENSES
Advertising	
Commissions	
Insurance	
Dues	
Legal	
Postage	
Printing	
Rent	
Supplies	
Taxes	
Travel	
Utilities	
Other	
Total expenses	
NET PROFIT	

ENTERTAINMENT/MEAL DOCUMENTATION

Date	Place of	Business	Relationship of Person	Amoun
	Entertain	Purpose	to Tax Payer	Spent
			### Total	
		A 2		
		- v		
		7		
				72
		2		
	1			
		7		
			7 3	
- Lange Marie				
		gar Tr. gas. Oga.		
A 11 80		100 mg 1 m		

DAILY MILEAGE REPORT

Date	Odo	ometer	Miles	Destination	Purpose
	Start	End			
	t in a second				
				•	
			6.4		
	-				
1 2					

TRAVEL DOCUMENTATION

Trip to	Business purpose
Date: From to	Number of days spent

Date	Place	Bkfst	Lunch	Dinner	Guests	Amount
						20X 2
	1					
				B 5		
		ing a A		7	Fag.	
	-					
		1			92	
		#	*		7.3	
	4					1 8.50
<i>d</i> - v						

STAPLE RECEIPTS TO BACK OF THIS FORM

PROJECTED BUDGET

MONTH OF						
		1. 1. 1.	NCOME			
Rentals				7.0		
Gallery						
Reps						
Patrons					1	
Shows				11.12		
Prints						4
Other						
Total Income						
		E	XPENSES			
Advertising						
Commissions				a		
Insurance						
Dues						
Legal						
Postage						
Printing						
Rent						
Supplies						
Taxes	-		1			
Travel				-,1	1	
Utilities		1 1 1 1 1 1				
Other	2 1					
Total Expenses						
NET PROFIT						

BALANCE SHEET

Date _____, ____

ASSETS				
Cash	\$			
Petty cash		_		
Accounts receivable	 - 1	<u>.</u>		
Inventory		-		
Prepaid expenses	 1	_		
Long term investments		_		
Equipment	 -	_		
Furniture	 -	_		
Auto/vehicle	 	_		
Misc assets		_		
Total assets		\$	_	_ (A)

LIABILITIES

Accounts payable \$ ______

Notes payable ______

Fed taxes payable ______

State taxes payable ______

Sales tax payable ______

Total liabilities \$_____(B

Total equity/net worth \$_____(C)

ASSETS = LIABILITIES + EQUITY (A = B + C)

CHECK RECONCILIATION FORM

OUTSTANDING CHECKS	新发发数
Check number	Amount
	edus, and
	no constallo
1 1 1 1 1 1 1 1 1 1 1 1 1 1 1 1 1 1 1	
	i i i i i i i i i i i i i i i i i i i
	1 1
	1 2 1 2 2 3 1 8 d V
Total outstanding checks (A	\$

Statement balance	(B)	\$	745	
Deposits not credited on this statement		\$		iai
80				2
	3			
				D 11
Total deposits	(C)	\$	7 76 5 1	
Total B + C	(D)	\$	F. 194	1300
Subtract A from D		()
Total should agree with your register bal	ance	\$	4779	hr 13

SECTION I GETTING STARTED

CHAPTER 3 LEGAL AGREEMENTS

The following sample contracts are just that: *samples* of what you might want to have a legal agreement contain. They are pro-artist. It is impossible to cover every contingency that might occur, so you must adapt these sample agreements to your specific situation. State laws vary and change. If you are given a contract by a gallery owner, remember that you can and should change clauses you don't agree with. Consult a lawyer whenever you enter into a contractual relationship. Always make two copies of any contract—one for you and one for the second party—dated and signed by all parties with original ink. Use common sense when drawing up contracts, and protect your rights as an artist.

If you want to be able to adapt these agreements to your personal needs, consider buying the computer diskette of this book's forms (an order form is in the back of this book).

Checklist for contracts

This is an outline or checklist for what many contracts need to contain—it is not a contract! Only in cases where large amounts of money and complexities of arrangements are involved would *all* these points be used.

Sales agreement

This serves as a receipt and record for the transfer of funds for the ownership of an artwork. It also states the artist's retention of reproduction rights. Use this agreement for professional sales, i.e., to a corporation. For private collectors, use the one on page 98.

Exhibition agreement

This documents the transfer of artwork without the transfer of ownership for the purpose of an exhibition. Outlining details makes sure everyone understands all aspects.

Artist-gallery agreement

A gallery will often want to use a legal agreement it has developed. Read it carefully, comparing it to this one. You might find some areas "twisted" to benefit the gallery!

Consignment schedule

Attach this schedule to any agreement, making it quite clear the pieces you are leaving are on consignment. According to the California Penal Code (section 536, subparagraph a), every merchant who sells consigned work must, upon written demand, provide the consignor (the Artist) with the names and addresses of the purchaser, the quantity of works sold, and the prices obtained.

Artist-gallery consignment agreement

This form is a shorter version of the combined *Artist-gallery agreement* and *Consignment schedule*. This document indicates transfer *for* sale, showing ownership is still in the hands of the artist. Should the gallery go bankrupt, for instance, it shows they are not the owners and their creditors cannot claim your artwork.

Work agreement

An important agreement if you want to keep rights to your creations when you are hired.

Model release

Use this release any time you are drawing from a live figure. You never know when you will use that drawing to help you in a final artwork displayed in the public. You could get sued by the model if you don't have one of these!

Property release

This is a similar form to the previous one but applying to property.

Commission agreement

Delete from or add to this contract details necessary for your particular project. After deciding to do a commission (whether portrait or other), you will need to spend time with the individual commissioning the piece, finding out specifics:

- what styles of work you've done that they like
- where the piece will be put
- size desired
- thoughts they have on the subject
- if it's a portrait, how they want subject posed
- time requirements

Giving them a rough sketch is a good idea so both parties are understood. Be sure to take several slides of the piece before you relinquish it. You may want to reproduce it for your promotional material or to accompany an article on your work.

Rental-lease agreement

This agreement is important whether it be signed by a large corporation or a private collector. Change the terms as you deem best. Keep it simple enough for a novice to comprehend.

Artist-agent agreement

If you're fortunate enough to hook up with a rep, don't neglect a formal agreement just because "he seems honest." Be careful with Paragraph 6. Attach a *Consignment Schedule* (page 36). This confirms you still own artwork until it is paid for.

Filling Out Application Form VA

Form VA

This is the form you send to Washington DC to copyright your art. It's fine to photocopy as many times as you deem necessary.

Art Office by Smith & Viders

CHECKLIST FOR CONTRACTS

	Parties involved
u	Parties involved
	Gallery: Continuity of personnel, location. Assignability.
_	Artist: Extension to spouse, children. Estate.
u	Duration. Fixed term, contingent on sales/productivity. Options to extend term. Different
_	treatment of sales at beginning and end of term.
	Scope. Media covered. Past and future work. Gallery's right to visit the studio. Commissions.
	Exclusivity. Territory, studio sales, barter or exchanges, charitable gifts.
	Shipping. Who pays to/from gallery. Carriers. Crating.
	Storage. Location, access by artist.
	Insurance. What's protected, in-transit/on-location.
	Framing. Who pays for framing; treatment of expense on works sold.
	Photographs. Who pays, amount required (B&W and color), ownership of negatives/
	transparencies, control of films.
	Artistic control. Permission for book/magazine reproduction. Inclusion in gallery group exhibits. Inclusion in
	other group exhibits. Artist's veto over purchasers.
	Gallery exhibitions. Dates. Choice of works to be shown. Control over installation. Advertising.
	Catalog. Opening. Announcements/mailings.
	Reproduction rights. Control prior to sale of work. Retention on transfer or sale of work.
	Copyrights.
	Damage/deterioration. Choice of restorer. Expense/compensation to artist. Treatment for
	partial/total loss.
	Protection of the market. Right of gallery to sell at auction. Protection of works at auction.
	Selling prices. Initial scale. Periodic review. Permission discounts. Negotiation of commissioned
	works. Right to rent vs. sell.
	Billing and terms of sale. Extended payment, credit risk, allocation of monies as received, division of
int	terest charges, qualified installment sale for tax purposes. Exchanges/trading up. Returns.
	Compensation of the gallery. Right to purchase for its own account.
	Income from other sales. Rentals. Lectures. Prizes/awards. Reproduction rights.
	Advances/guarantees. Time of payment. Amounts and intervals. Application to sales.
	purchasers. Right of gallery to use artist's name and image for promotional purposes.
	General provisions. Representations and warranties. Applicable law. Arbitration.
_	

SALES AGREEMENT ___ day of _____, ___, between _ Agreement made this ____ _(hereinafter called "the Artist"), residing at _ _, and _ _ (hereinafter called "the Purchaser"), residing at ___ I. DESCRIPTION OF WORK. Title_ Medium Year created 2. PAYMENT. The Artist shall sell the Work to the Purchaser, subject to the conditions herein, for a price of \$_ (dollars). The Purchaser shall also pay all applicable taxes. 3. INSURANCE, SHIPPING, AND INSTALLATION. The Artist agrees to keep the Work fully insured against fire and theft until delivery to the Purchaser. In the event of a loss caused by fire or theft, the Artist shall use the insurance proceeds to recommence the making of the Work. The Work shall be shipped F.O.B. Artist's studio at the expense of the Purchaser to the address above. 4. ARTIST'S RIGHTS. a. Copyright and Right to Credit. The Artist reserves all rights of reproduction and all copyright on the Work, the preliminary design, and any incidental works made in the creation of the Work. The Work may not be photographed, sketched, painted, or reproduced in any manner whatsoever without the express written consent of the Artist. b. Right to Possession. The Artist and the Purchaser agree that the Artist shall have the right to show the Work for up to sixty (60) days once every five (5) years at no expense to the Purchaser, upon written notice not later than ninety (90) days before opening of show and upon satisfactory proof of insurance. All costs incurred from door-to-door will be the responsibility of the Artist. c. Non-destruction/Alteration. The Purchaser agrees that he/she will not intentionally destroy, alter, damage, modify, or otherwise change the Work in any way whatsoever, without the Artist's written permission. d. Repairs/Maintenance. The Purchaser shall be responsible for the proper cleaning, maintenance, and protection of the Work in his/her possession, if on loan or otherwise exhibited, notwithstanding anything contrary herein. All repairs and restorations made during the Artist's lifetime shall have the Artist's written permission. The Artist shall be consulted as to his/her recommendations with regard to all such repairs and restorations, and will be given the opportunity to accomplish such repairs as he/she deems necessary. In that event the Work will no longer be represented as the Work of the Artist without his/her written permission. e. Resale of Work. If the Purchaser sells or transfers the Work, the Purchaser shall pay to the Artist a sum equal to fifteen percent (15%) of the appreciated value of the work and shall obtain from the new purchaser or transferee a binding undertaking to observe all of the provisions of this Agreement in the interest of the Artist. The Artist shall be given the new owner's name and address. For the purposes of this agreement, appreciated value shall mean the sales price of the artwork less the original purchase price as stated in this agreement. 5. NOTICES AND CHANGES OF ADDRESS. All notices shall be sent to the addresses noted above. Each party shall give written notification within sixty (60) days of any changes of address. 6. NO ASSIGNMENT OR TRANSFER. Neither party hereto shall have the right to assign or transfer this agreement without the prior written consent of the other party. 7. HEIRS AND ASSIGNS. This agreement shall be binding upon the parties hereto, their heirs, successors, assigns, and personal representatives, and references to the Artist and the Purchaser shall include their heirs, successors, assigns, and personal representatives. 8. SEVERABILITY. If any part of this Agreement is held to be illegal, void, or unenforceable for any reason, such holding shall not affect the validity and enforceability of any other part. 9. GOVERNING LAWS. The validity of this agreement and of any of its terms, as well as the rights and duties of the parties under this agreement, shall be governed by the laws of the State of _____ IN WITNESS WHEREOF the parties have hereunto set their hands this date of ____

PURCHASER

ARTIST

EXHIBITION AGREEMENT

This is an agreement entered into on, between						
("Artist") and (Name of space and/or owner), an exhibition space ("purpose of this agreement is to set out the understandings which shall govern an exhibit by Artist of certain in such Space. The exhibit shall be on public view from through The space s						
to the public from am topm, (M-F, Sat only, etc.). The op atpm.	ening shall be neld or					
atrm.						
Artist shall have access to the Space for preparation, storage of works and installation day and shall have days after the exhibit closes within which to remove art works from the disposition of works not removed by that time will be made solely by Space owner.						
Artistic judgment with respect to installation of the work in the Space shall rest solely withinstallation fixtures, including mountings, tape, pins, nails, etc., as required.	Space shall provide					
Upon request of Space, by, Artist shall advise the Space of the approximate works to be installed and shall provide to the Space a schedule of titles, descriptions, prices an each work.	e number and types o d insurance values fo					
Space shall insure the works for the values assigned by the Artist from the period when the Artist to Space until removal of works by the Artist or until the date all works must be removed from Space is responsible for security of works in storage areas and also during all hours when the eview. Space represents that it is in sound repair and Space shall be responsible for damage to the structural defects, water damage or the like. Space shall exercise reasonable care in dealing wishall be removed during the period of the exhibit and buyers of any work shall be informed of	ace, whichever is later exhibit is not on public e works occasioned by th the works. No work					
Commission on sale of works on exhibit shall be%.						
All publicity shall state the name and address of the Space. Artist shall be responsible for publicity and prom including posters, any catalog, announcements and the mailing thereof, news coverage by newspaper, magazine, or television, paid advertising, except as follows:						
Artist shall arrange and be financially responsible for refreshments at the opening.						
The Space shall maintain the Space in a good state of repair, clean and orderly.						
All disputes arising out of this Agreement shall be submitted to final and binding arbitration. Selected in accordance with the rules of Arbitration and Mediation Services. If such service is no shall be submitted to arbitration in accordance with the laws of The arbitrator's award udgment may be entered upon it by any court having jurisdiction thereof.	ot available the dispute					
Both parties agree that this represents the entire understanding between them, and that it shall be a the signature by an authorized representative of the Space and the Artist.	binding contract upor					
SIGNATURE OF SPACE OWNER/AUTHORIZED REPRESENTATIVE	Date					
	DAIL					

Art Office by Smith & Viders

ARTIST-GALLERY AGREEMENT

and ((Callery!))
and ("Gallery"), at The terms of this Agreement are as follows:
1. Limited, Exclusive Agency. Artist hereby appoints Gallery his exclusive/non-exclusive agent for the sale and exhibition
of his works of art in the following geographical area: The Gallery shall have the
right of first selection of works produced by Artist for inclusion in the show(s) which it will present. Any works not selected
by the Gallery may be sold by the Artist.
2. Creation, Title and Receipt. Artist hereby warrants that he created and possessed unencumbered title to, and Gallery
acknowledges receipt of, the works of art on the attached Consignment Schedule ("the Schedule").
3. Sales. Sales shall be made at a price not less than the price ("Retail Price") on Schedule, which doesn't include sales
tax or delivery costs. The Gallery will supply the Artist with its signed resale certificate and its resale number for Artist's
records. Gallery shall receive % of the sales price on sales or commissions made by Gallery; % of the sales
price on sales made directly by the Artist; % of the rental fees on rentals arranged by the Gallery; % of the amount
received for prizes and awards granted to the Artist when such prizes and awards are obtained for the Artist by the Gallery;
% of lecture fees for lectures arranged for the Artist by the Gallery. The Gallery may give a trade discount which
shall not exceed% of sales price without the Artist's written consent on sales to museums, galleries, decorators and
architects. In the case of such discount sales, the amount of the discount shall be deducted from the Gallery's sales
commission. The Gallery shall use its best efforts to promote the sale of the Artist's consigned works, to support a market
for the Artist's work, and to provide continuous sales representation in the following manner:
for the Artist's work, and to provide continuous sales representation in the following manner.
4. Reserved on Callanda Salas. On autright calculation hall now Artist the balance of calculation after its commission
4. Payment on Gallery's Sales. On outright sales: Gallery shall pay Artist the balance of sales price after its commission within thirty (20) days of payers payment to Gallery. If payer has or pays in installments, all monies received by Gallery
within thirty (30) days of purchaser's payment to Gallery. If purchaser pays in installments, all monies received by Gallery
from purchaser shall be distributed pro rate to Artist and Gallery in accordance with their respective percentage shares
of the total sale price, and Artist's share shall be paid within thirty (30) days of Gallery's receipt of any installment payment
until Artist's share is paid in full. It is expressly agreed that any default of a purchaser from Gallery shall be borne solely
by Gallery and Gallery shall, notwithstanding such default, pay Artist his percentage share of sales price within one
hundred eighty (180) days of any such sale on installment terms.
5. Payment on Artist's Sales. The Gallery shall receive % of any sales made by the Artist personally, without the
assistance of the Gallery, provided, however, that no commission shall be paid on any sales referred to in this paragraph,
unless the Gallery makes sales in the contract year of at least \$ for the Artist. Artist shall pay Gallery its commission
within thirty (30) days of the purchaser's payment to Artist. If purchaser pays in installments, Artist shall pay Gallery its
percentage share of each payment by purchaser to Artist within thirty (30) days of Artist's receipt of any installment
payments.
6. Commissions. Gallery shall be entitled to receive % of the price of any commissions given to Artist to create
works of art when such commissions are obtained for him by Gallery, and % of any such creation commissions
Artist procures during the term of this Agreement.
7. Exhibitions. During the term of this agreement, Gallery shall hold at least solo exhibition(s) every months
for Artist and shall use its best efforts to arrange other solo exhibition(s) for Artist and for the inclusion of Artist's work in
group exhibitions in other galleries or museums, provided, however, that Artist's work may not be included in any group
exhibition without his prior written consent. Failure to do so shall entitle Artist to terminate this Agreement upon thirty
(30) days written notice to Gallery. Although the Gallery may arrange for representation of the Artist by another agency
with the Artist's written consent, the Gallery shall pay such agency by splitting its own commission. When the Artist has
a one-man show at the Gallery, all related costs will be borne by the Gallery for such exhibition; including, but not limited
to, advertising, printing, reception, framing, packing and freight. Should the Gallery lend out for approval to a client a
piece of Artwork by said Artist, the Gallery will be responsible for Artist's commission if work is stolen, lost or damaged,
just as in a sale. Should the piece not be returned within seven days, it will be considered sold by Artist, and Artist will
expect his commission in due time as provided in this contract. Should the Artist give the Gallery his/her mailing list to
use for any exhibit, the Gallery shall respect confidentiality of same and only use it for the Artist's personal show. After
the exhibition, frames, photographs, negatives and any other tangible property created in the course of the exhibition shall
be the property of the Artist. The shall bear the cost of shipping the works to the Gallery. The shall
bear the cost of framing. The Gallery shall bear all other costs incident upon the show. The Artist shall be free to exhibit
and sell any work not consigned to the Gallery under this Agreement.

Artist Date	calendar quarter. The Statement shall detail Artist's works sold/rented/leased during the calendar quarter (to include at least price, date, name and address of purchaser), payments made to Artist, payments owed Artist on installment purchases, and location of any unsold work not located at Gallery. 10. Reproduction Rights. Artist hereby reserves for himself the right to copy, photograph or reproduce each of the works of art consigned to Gallery. Callery agrees that it will not permit any of the works of art to be copied, photographed or reproduced except for the purpose of appearing in a catalog or advertisement without the prior written consent of Artist and will state "The right to copy, photograph or reproduce the work(s) of art identified herein is reserved by the Artist." Notwithstanding the foregoing, reproduction rights may be specifically sold by Gallery with the Artist's prior written consent. Gallery shall not receive any commissions on royalties or licensing of reproduction rights unless sold or arranged by Gallery, in which case Gallery's commissions on these procurements. 11. Insurance. Gallery will provide all-risk insurance on Artist's works of art listed on the Schedule of up to% of retail price. 12. Termination of Agreement. This Agreement shall terminate on Upon termination, Gallery shall return within thirty (30) days all Artist's works of art which are held on consignment. 13. Return of Works. All Costs of return (including packing, transportation and insurance) shall be paid as follows:% by the Artist, % by the Callery. The Gallery may return any consigned work on thirty (30) days written notice. If the Artist fails to accept return of the works within days after written request by the Gallery, the Artistshall pay reasonable storage costs. The Gallery agrees to return consigned works in the same good condition as received. 14. Loss of Damage. The Gallery shall not intentionally commit or authorize any physical defacement, mutilation, alt	
Artist Date		
Artist		
	Artist Date	
Gallery Owner/Agent Date	GALLERY OWNER/AGENT DATE	
Gallery Owner/Agent Date	Gallery Owner/Agent Date	

CONSIGNMENT SCHEDULE

Artist	to a serve from		
Address			
City/State/Zip			
Telephone		38	
Consignee			
Address	2 3 An	and the	
City/State/Zip		1.7% (3.16)	the state
Telephone	Leader	y vin	31

Title/Description	Medium	Size	Framed	Retail \$	Commission	Net \$
		yaa				
Laborate Space and the second		1 1 1 1 1 1 1 1 1 1 1 1 1 1 1 1 1 1 1				73
and a second second						7
Angel Carles and						
	1		1			
				50 1 1 1 1 1 1 1 1 1 1 1 1 1 1 1 1 1 1 1		
	1 S N		ATE			
1000		i di jaya	i en la la			
	- 4	2	T va		0	
d Sexes	~				20 m 1 m 2	
TO A CONTRACTOR	1.4		8 12			
2		gart on the		2. 7		102
ARTIST					Date	
Consignee					Date	

ARTIST-GALLERY CONSIGNMENT AGREEMENT

The Gallery confirms receipt of the Artist's consigned artworks, in perfect condition unless otherwise noted, as follows:

Title/Description	Medium	Size	Framed	Retail \$	Comm	Net \$
at which to the	100					
					19 mg/1/2	

- 2. This agreement applies only to works consigned under this agreement.
- 3. The Artist reserves the copyright and all reproduction rights to these works. The Gallery *will not* permit any of the artworks to be copied, photographed, reproduced or transferred to a CD-ROM for use on a computer network without my written permission. The Gallery will print on each bill of sale, "The right to copy, photograph or reproduce the artwork(s) identified here is reserved by the Artist, _____."
- 4. The retail amount (less the Gallery commission) and the name and address of the purchaser will be remitted to the Artist within thirty (30) days after the sale. The title to these works remains with the Artist until the works are sold and the Artist is paid in full, at which time the title passes directly to the purchaser.
- 5. The Gallery will assume full responsibility for any consigned work lost, stolen or damaged while in its possession. Consigned works *may not* be removed from Gallery premises for purposes of rental, installment sales or approval with a potential purchaser without the Artist's permission. The specified retail prices *may not* be changed without the Artist's permission.
- 6. The consigned works will be held in trust for the Artist's benefit and will not be subject to claim by a creditor of the Gallery. This agreement will terminate automatically upon the Artist's death, or if the Gallery becomes bankrupt or insolvent. Either party may terminate this agreement by giving thirty (30) days written notice, with all accounts settled.

Gallery Name	ž.		Artist Name	1 =1 =	
Address	11 14 deg		Address	T 2	
City	State	Zip	City	State	Zip
Phone			Phone		
Signature of Galle	ery Director		Signature of Artist		

WORK AGREEMENT

Agreement made this	_ day of	, between
		_ (hereinafter "Company") and
	(hereinaft	ter "Artist") for the preparation of
artwork(s) for the		(hereinafter "Project").
Witnesseth: NOW, WHEREFORE, in consideration of	of the mutual	covenants and promises set forth
herein, the parties agree as follows:	or the mutual t	covenants and promises sectorul
Artist shall submit the artworks in fire	nished form n	no later than
2. Company will pay Artist the sum of Shalf upon delivery of preliminary studiartwork.		
3. Any and all artwork created pursipossession of the Artist, including copthroughout the world, except for the sp	yright to the	work, for any and all purposes
4. Artist represents and warrants that herein, that it does not infringe on any rof privacy of any person or entity and obtained.	rights of copyr	right or personal rights and rights
5. Artist agrees that he/she is working will be responsible for payment of all exartwork.		
IN WITNESS WHEREOF, the parties her and year first above written.	reto have duly	executed the agreement the day
COMPANY		Date
Artist		Date

MODEL RELEASE

On, I,	, posed as a model for
artwork (to be) created by	In consideration of
he payment of the sum of \$ at the conclu- hereby grant the irrevocable right to the use of my n any and all manners including composite or so preparation of works of art or any other lawful purp approval/rejection of the completed works which manarmless the Artist and the Artist's representatives a herein.	likeness in any and all media and segmented representation for the pose. I hereby waive my rights to ay incorporate my image, and hold
am an adult living in the State of I have read	this model release and understand
ts contents.	
Date	<u> </u>
Model	
Address	
If model is minor	
As Parent/Guardian of the above-named Model who all the terms stated above and accept on behalf of the above.	
Date	<u> </u>
Parent/Guardian	

PROPERTY RELEASE

I hereby grant the irrevocable right, as owner of property noted below, to use of the likeness in any and all media and in any and all manners including composite or segmented representation for the preparation of works of art or any other lawful purpose.

I hereby waive my rights to approval/rejection of the completed works which may incorporate said property, and hold harmless the Artist and the Artist's representatives against any and all liability arising herein.

I am an adult living in the State of _	I have read this property release and
understand its contents.	

Date	
Owner of property	
Address of property	
Description of property	
Signature of owner	

COMMISSION AGREEMENT

This Agreement is made the da	y of, between	("Artist") residing at ("Purchaser") residing at
Arti	ist agrees to execute the "Comm oned Work subject to the terms	and conditions of this Agreement. A description
purchase price of \$ in two or three this Agreement and is non-refundable Commissioned Work, of which Artist withe final payment and sign a purchase and belivery, INSURANCE, INSTALLATION the satisfaction of the Purchaser prior to of the Commissioned Work as executed liable for payment of the second installated livered. Ownership of the Commissioned work as executed liable for payment of the second installated livered. Ownership of the Commissioned work as executed liable for payment of the second installated livered. Ownership of the Commissioned work and theft until delivery under such circle fire and theft until delivery under such circle fire and theft until delivery to the Purchaser shall of the Artist agrees to make delivery within such period, Artist be entitled to refuse to accept delivery. Purchaser shall not be entitled to recovall rights therein shall remain with the COPYRIGHT, OWNERSHIP. Commissioned Work. Copies of finisher RESALE RIGHTS. If the Purchaser sells, Work to another person, the Purchaser In the case of transfer, the appreciated Work at the time of transfer and the tota Article if the Purchaser donates the Comclaims a tax deduction in respect of such difference between such deduction and NON-DESTRUCTION. The Purchaser Commissioned Work. All repairs and recommissioned work.	equal installments. The first in. The final payment shall be ill give five (5) days notice. The land sales agreement. ON. Artist shall make a good fat delivery. In the event, however, I (whether such refusal is reasonent of the total purchase price oned Work and all rights there cumstances. Artist agrees to kee chaser and bear any other risk Artist. It deliver Commissioned Work that is to make delivery on or before of the Commissioned Work and the fails to make delivery on or before payment of the first installment of the Commissioned Work are payment of the first installment of the Fir	nates, or otherwise transfers the Commissioned to fifteen (15) per cent of the appreciated value. ween the fair market value of the Commissioned tement. No payment shall be required under this or other nonprofit institution, unless the Purchaser Purchaser shall pay the Artist a sum equal to the
Commissioned Work for a period not exhibition. If the Purchaser intends to exhibition. If the Purchaser intends to exhibition of the exhibition, and the name of for exhibition of the Commissioned Worgives to the Artist permission to use the in all manners, including but not limited Purchaser's rights of privacy. MISCELLANEOUS. Each party shall give	sceeding sixty (60) days during shibit the Commissioned Work pour notice shall include the nathe curator or other person respork shall be divided equally betwoed to exhibition, display, advertige written notification to other pagreement shall be submitted to eas of The arbitral	nable notice to the Purchaser, to borrow the any one (1) year period for the purpose of public publicly, he/she shall notify the Artist not less than ame and address of the exhibiting institution, the consible for the exhibition. The rental fee (if any) ween the Artist and the Purchaser. The Purchaser trait and photograph in all forms and media and ising, trade and editorial uses, without violating arty of change of address prior to the date of said final and binding arbitration. The arbitrator shall ator's award shall be final and judgment may be
Artist	Date Purchase	r Date

RENTAL-LEASE AGREEMENT

Renter/Leasor			
Address			
City/State/Zip			en de la lagrandigación
Telephone	ar ar Paralystatics		er en en en en en
			e la
Artist/Agent			
Address			Es e e e e e e e e e e e e e e e e e e e
City/State/Zip			11 Venes 25
Telephone		A CONTRACT OF THE SECOND SECON	
garder and			
Overdue charge	of \$ per day Pe	antal and ronowal food are	navable in advance
 Renter/leasor sh whatever cause not be transferr At the expiratio to return said p 	nall be responsible dui , including fire and the ed to another person n, termination or defa roperty to artist in ori	eft. Artwork may not be pair 's care. ult of this Rental/Lease Agre iginal condition.	payable in advance. amage to said property from nted or altered. Artwork may eement, renter/leasor agrees
 Renter/leasor sh whatever cause not be transferr At the expiratio to return said p Title	nall be responsible dui , including fire and the ed to another person n, termination or defa roperty to artist in ori	ring rental term for loss or da eft. Artwork may not be pair 's care. ult of this Rental/Lease Agra iginal condition.	amage to said property from nted or altered. Artwork may eement, renter/leasor agrees
 Renter/leasor sh whatever cause not be transferr At the expiratio to return said p Title Medium 	nall be responsible dui , including fire and the ed to another person n, termination or defa roperty to artist in ori	ring rental term for loss or da eft. Artwork may not be pair 's care. ault of this Rental/Lease Agre iginal condition.	amage to said property from nted or altered. Artwork may eement, renter/leasor agrees
 Renter/leasor sh whatever cause not be transferr At the expiration to return said p Title Medium List any abnormal 	nall be responsible duit, including fire and the ed to another person n, termination or defaroperty to artist in ori	ring rental term for loss or da eft. Artwork may not be pair 's care. ult of this Rental/Lease Agra iginal condition.	amage to said property from nted or altered. Artwork may eement, renter/leasor agrees
 Renter/leasor sh whatever cause not be transferr At the expiration to return said p Title Medium List any abnormal 	nall be responsible duit, including fire and the ed to another person n, termination or defaroperty to artist in ori	ring rental term for loss or da eft. Artwork may not be pair 's care. ult of this Rental/Lease Agre iginal condition. Size	amage to said property from nted or altered. Artwork may eement, renter/leasor agrees
 Renter/leasor sh whatever cause not be transferr At the expiration to return said p Title Medium List any abnormal Start date 	nall be responsible duit, including fire and the ed to another person n, termination or defaroperty to artist in ori	ring rental term for loss or da eft. Artwork may not be pair 's care. ult of this Rental/Lease Agre iginal condition. Size	amage to said property from nted or altered. Artwork may eement, renter/leasor agrees
 Renter/leasor sh whatever cause not be transferr At the expiration to return said p Title Medium List any abnormal Start date 	nall be responsible duit, including fire and the ed to another person n, termination or defaroperty to artist in ori	ring rental term for loss or da eft. Artwork may not be pair 's care. ult of this Rental/Lease Agre iginal condition. Size ere: Rental Fee	amage to said property from nted or altered. Artwork may eement, renter/leasor agrees
2. Renter/leasor sh whatever cause not be transferr 3. At the expiration to return said p Title Medium List any abnormal Start date This agreement is a	nall be responsible duit, including fire and the ed to another person n, termination or defaroperty to artist in ori	ring rental term for loss or da eft. Artwork may not be pair 's care. ult of this Rental/Lease Agre iginal condition. Size ere: Rental Fee	amage to said property from nted or altered. Artwork may eement, renter/leasor agrees
 Renter/leasor sh whatever cause not be transferr At the expiration to return said p Title Medium List any abnormal Start date 	nall be responsible duit, including fire and the ed to another person n, termination or defaroperty to artist in ori	ring rental term for loss or da eft. Artwork may not be pair 's care. ult of this Rental/Lease Agre iginal condition. Size ere: Rental Fee	amage to said property from the dor altered. Artwork may be ement, renter/leasor agrees Sales Price

Art Office by Smith & Viders

ARTIST-AGENT AGREEMENT

This Agreement is made the day of, _ "The Artist"), residing at	and
The Autot // Testaing at	("The Agent"), residing a
The parties agree as follows:	
	xclusive agent for the purpose of representation and sale of
works of art within the following geographical area:	
1. Fee	
Artist shall secure the services of Agent by advance pa sales for the Artist. Retainer fee covers a minimum o 2. Duties of Agent	yment of a retainer fee of \$ per month to initiat of hours of work per month.
Agent agrees to use reasonable efforts in the perform	ance of the following duties: promote and publicize Artist
name and talents; carry on business correspondence cooperate with duly constituted and authorized repre- shall fully comply with all applicable laws, rules ar	ce on Artist's behalf relating to Artist's professional caree esentatives of Artist in the performance of such duties. Ager nd regulations of governmental authorities and secure suc
licenses as may be required for the rendition of serv	rices hereunder.
3. Rights of Agent	and the second s
the Artist. Agent shall have the right to use or to peri	rtists. Agent may publicize the fact the Agent is the agent for mit others to use Artist's name and likeness in advertising of commissions, rentals, or public showing but without cost of ically agree in writing.
	agent and offered for sale at the retail price listed on attache
Consignment Schedule. Agreed upon retail price can they shall come from the Agent's sales commission. % of the retail price. The remainder shall be paid to th	be lowered by no more than 10%. If other discounts are give The Agent shall receive the following sales commission: e Artist. Artist agrees to refrain from any and all unauthorize tomer relationships and/or agreements entered into betwee
On outright sales, the Agent shall pay the Artist's shar sales, the Agent shall first apply the proceeds from sal	re within thirty (30) days after the date of sale. On installmente of the work to pay the Artist's share. Payment shall be made in installment. Late payment shall be accompanied by interest.
6. Delivery	
All costs of delivery (including transportation and ir deliveries back to artist will be paid by the Agent. 7. Title & Receipt	nsurance) to Agent's address shall be paid by The Artist. A
Artist warrants that he/she created and possesses un under this Agreement. Title to the consigned work sha acknowledges receipt of the works described on the	nencumbered title to all works of art consigned to the Age all remain with the Artist until he/she is paid in full. The Age e Consignment Schedule.
8. Sales Price The Agent shall sell the consigned works at the who Consignment Schedule. The Agent shall have discre	olesale price asked by Artist and specified in writing on the
9. Loss or Damage	
of any of the consigned works. Agent shall be respo of consigned works, and shall also be responsible for	y physical defacement, mutilation, alteration, or destruction is sible for the proper cleaning, maintenance, and protection the loss or damage of consigned works, whether the works protected the property of
10. Statements of Account	on rental/lease or otherwise removed from its premises.
Agent shall give the Artist a Statement of Account w	ithin fifteen (15) days after the end of each calendar quar

of sale or rental, commission due to the Artist, the name and address of each purchaser or renter, and the location of all unsold works. Agent warrants that the Statement shall be accurate and complete in all respects. Artist (or his/ her authorized representatives) shall have the right to inspect the financial records of Agent pertaining to any transaction involving the Artist's work. The Agent shall keep the books and records at the Agent's place of business and the Artist may make inspection during normal business hours on the giving of reasonable notice, no more than twice a year. 11. Contract for Sale The Agent shall, at his/her own discretion, determine the appropriate form of contracts for sale of Artist's work to third parties. 12. Copyright The Artist reserves all reproduction rights on all works consigned to the Agent. No work may be reproduced by the Agent without the prior written approval of the Artist. All approved reproductions in catalogs, brochures, advertisements, and other promotional literature shall carry the following notice: "Title" by (name of the Artist) and year of artwork. 13. Duration of Agreement This Agreement shall commence upon the date of signing and shall continue in effect until the _ . Either party may terminate the Agreement by giving thirty (30) days prior written notice. If terminated by Artist, Agent continues to receive "royalties" of ___ % on all sales for period in association with work originally obtained. If Agent dissolves agreement, Agent owes Artist a gross figure to bring artist's yearly earnings up to previous year's earnings. If yearly gross income is not less than previous year, Agent owes Artist nothing. Agent relinquishes all rights to commissions except for 5% royalty on all sales or re-sales associated with Agent's original negotiations. Artist agrees to refrain from entering into any agreements with Agent-received accounts for a period of 18 months after the term of this Agreement. However, Artist may enter into a direct relationship with Agent's established accounts and customers within this 18 months with the express written approval and consent of the Agent, provided that the Artist pays to the Agent the commission that would have been charged under the terms and conditions of this Agreement had this Agreement remained in full force. 14. Assignment This Agreement shall not be assigned by either of the parties hereto. It shall be binding on and inure to the benefit of the successors, administrators, executors, or heirs of the Agent and Artist. 15. Independent Contractor Status Both parties agree that the Agent is acting as an independent contractor. This Agreement is not an employment agreement, nor does it constitute a joint venture or partnership between the Artist and Agent. 16. Return of Works Agent shall be responsible for return of all works not sold upon termination of the Agreement. All costs of return, including transportation and insurance, shall be paid as follows: __% by the Artist, if Artist dissolves; __% by the Agent, if Agent dissolves. 17. Arbitration All disputes arising out of this Agreement shall be submitted to final and binding arbitration. The arbitrator shall be selected in accordance with the rules of Arbitration and Mediation Services. The arbitrator's award shall be final, and judgment may be entered upon it by any court having jurisdiction thereof. 18. Entire Agreement This Agreement represents the entire agreement between the Artist and the Agent and supersedes all prior negotiations, representations and agreements whether oral or written. This Agreement may only be amended by a writing instrument signed by both parties. 19. Governing Law This Agreement shall be governed by the laws of the State of _ IN WITNESS WHEREOF the parties hereto have executed this Agreement on the day and year first above written.

DATE

DATE

ARTIST

AGENT

Filling Out Application Form VA

Detach and read these instructions before completing this form. Make sure all applicable spaces have been filled in before you return this form.

BASIC INFORMATION

When to Use This Form: Use Form VA for copyright registration of published or unpublished works of the visual arts. This category consists of "pictorial, graphic, or sculptural works," including two-dimensional and three-dimensional works of fine, graphic, and applied art, photographs, prints and art reproductions, maps, globes, charts, technical drawings, diagrams, and models.

What Does Copyright Protect? Copyright in a work of the visual arts protects those pictorial, graphic, or sculptural elements that, either alone or in combination, represent an "original work of authorship." The statute declares: "In no case does copyright protection for an original work of authorship extend to any idea, procedure, process, system, method of operation, concept, principle, or discovery, regardless of the form in which it is described, explained, illustrated, or embodied in such work."

Works of Artistic Craftsmanship and Designs: "Works of artistic craftsmanship" are registrable on Form VA, but the statute makes clear that protection extends to "their form" and not to "their mechanical or utilitarian aspects." The "design of a useful article" is considered copyrightable "only if, and only to the extent that, such design incorporates pictorial, graphic, or sculptural features that can be identified separately from, and are capable of existing independently of, the utilitarian aspects of the article."

Labels and Advertisements: Works prepared for use in connection with the sale or advertisement of goods and services are registrable if they contain "original work of authorship." Use Form VA if the copyrightable material in the work you are registering is mainly pictorial or graphic; use Form TX if it consists mainly of text. NOTE: Words and short phrases such as names, titles, and slogans cannot be protected by copyright, and the same is true of standard symbols, emblems, and other commonly used graphic designs that are in the public domain. When used commercially, material of that sort can sometimes be protected under state laws of unfair competition or under the sometimes be protected under state laws of unfair competition or under the Federal trademark laws. For information about trademark registration, write to the Commissioner of Patents and Trademarks, Washington, D.C. 20231.

Architectural Works: Copyright protection extends to the design of buildings created for the use of human beings. Architectural works created on or after December 1, 1990, or that on December 1, 1990, were unconstructed and embodied only in unpublished plans or drawings are eligible. Request Circular 41 for more information.

Deposit to Accompany Application: An application for copyright registration must be accompanied by a deposit consisting of copies representing the entire work for which registration is to be made.

Unpublished Work: Deposit one complete copy.

Published Work: Deposit two complete copies of the best edition.

Work First Published Outside the United States: Deposit one complete copy of the first foreign edition.

Contribution to a Collective Work: Deposit one complete copy of the best edition of the collective work.

The Copyright Notice: For works first published on or after March Ine Copyright Notice: For works first published on or after March 1, 1989, the law provides that a copyright notice in a specified form "may be placed on all publicly distributed copies from which the work can be visually perceived." Use of the copyright notice is the responsibility of the copyright owner and does not require advance permission from the Copyright Office. The required form of the notice for copies generally consists of three elements: (1) the symbol "6", or the word "Copyright," or the abbreviation "Copr."; (2) the year of first publication; and (3) the name of the owner of copyright. For example: "© 1995 Jane Cole." The notice is to be affixed to the copies "in such manner and location as to give reasonable notice of the claim of copyright." Works first published prior to March 1. 1989, must carry the notice or risk loss Works first published prior to March 1, 1989, must carry the notice of risk loss of copyright protection.

For information about notice requirements for works published before March 1, 1989, or other copyright information, write: Information Section, LM-401, Copyright Office, Library of Congress, Washington, D.C. 20559-6000.

LINE-BY-LINE INSTRUCTIONS Please type or print using black ink.

SPACE 1: Title

Title of This Work: Every work submitted for copyright registration must be given a title to identify that particular work. If the copies of the work bear a title (or an identifying phrase that could serve as a title), transcribe that wording completely and exactly on the application. Indexing of the registration and future identification of the work will depend on the information you give here. For an architectural work that has been constructed, add the date of construction after the title; if unconstructed at this time, add "not yet constructed."

Previous or Alternative Titles: Complete this space if there are any additional titles for the work under which someone searching for the registration might be likely to look, or under which a document pertaining to the work might

Publication as a Contribution: If the work being registered is a contribution to a periodical, serial, or collection, give the title of the contribution in the "Title of This Work" space. Then, in the line headed "Publication as a Contribution," give information about the collective work in which the contribution appeared.

pictorial, graphic, or sculptural work being registered for copyright. Examples: "Oil Painting"; "Charcoal Drawing"; "Etching"; "Sculpture"; "Map"; "Photograph"; "Scale Model"; "Lithographic Print"; "Jewelry Design"; "Fabric Design." Nature of This Work: Briefly describe the general nature or character of the

2 SPACE 2: Author(s)

General Instruction: After reading these instructions, decide who are the "authors" of this work for copyright purposes. Then, unless the work is a "collective work," give the requested information about every "author" who contributed any appreciable amount of copyrightable matter to this version of the work. If you need further space, request Continuation Sheets. In the case of a collective work, such as a catalog of paintings or collection of cartoons by various authors, give information about the author of the collective work as a whole

Name of Author: The fullest form of the author's name should be given. Unless the work was "made for hire," the individual who actually created the work is its "author." In the case of a work made for hire, the statute provides work is its autor. In the case of a work made for hire, the statute provides that "the employer or other person for whom the work was prepared is considered the author."

What is a "Work Made for Hire"? A "work made for hire" is defined as: (1) "a work made for hire"? A "work made for hire" is defined as: (1)
"a work prepared by an employee within the scope of his or her employment";
or (2) "a work specially ordered or commissioned for use as a contribution to
a collective work, as a part of a motion picture or other audiovisual work, as a
translation, as a supplementary work, as a compilation, as an instructional text, translation, as a supplementary work, as a compilation, as an instructional text, as a test, as answer material for a test, or as an atlas, if the parties expressly agree in a written instrument signed by them that the work shall be considered a work made for hire." If you have checked "Yes" to indicate that the work was "made for hire," you must give the full legal name of the employer (or other person for whom the work was prepared). You may also include the name of the employee along with the name of the employer (for example: "Elster Publishing Co., employer for hire of John Ferguson").

"Anonymous" or "Pseudonymous" Work: An author's contribution to a work is "anonymous" if that author is not identified on the copies or phonorecords of the work. An author's contribution to a work is "pseudonymous" if that author is identified on the copies or phonorecords under a fictitious name. If the work is "anonymous" you may: (1) leave the line blank; or (2) state "anonymous" on the line; or (3) reveal the author's identity. If the work is "pseudonymous" you may: (1) leave the line blank; or (2) give the pseudonym and identify it as such (for example: "Huntley Haverstock, pseudonym"); or (3) reveal the author's name, making clear which is the real name and which is the pseudonym (for example: "Henry Leek, whose pseudonym is Priam Farrel"). However, the citizenship or domicile of the author must be given in all cases.

Dates of Birth and Death: If the author is dead, the statute requires that the year of death be included in the application unless the work is anonymous or pseudonymous. The author's birth date is optional but is useful as a form of identification. Leave this space blank if the author's contribution was a "work made for him." made for hire.

Author's Nationality or Domicile: Give the country of which the author is a citizen or the country in which the author is domiciled. Nationality or domicile must be given in all cases.

Nature of Authorship: Catagories of pictorial, graphic, and sculptural authorship are listed below. Check the box(es) that best describe(s) each author's contribution to the work.

3-Dimensional sculptures: fine art sculptures, toys, dolls, scale models, and sculptural designs applied to useful articles.

2-Dimensional artwork: watercolor and oil paintings; pen and ink drawings; logo illustrations; greeting cards; collages; stencils; patterns; computer graphics; graphics appearing in screen displays; artwork appearing on posters, calendars, games, commercial prints and labels, and packaging, as well as 2-dimensional artwork applied to useful articles.

Reproductions of works of art: reproductions of preexisting artwork made by, for example, lithography, photoengraving, or etching.

Maps: cartographic representations of an area such as state and county maps, at lases, marine charts, relief maps, and globes.

Photographs: pictorial photographic prints and slides and holograms.

Designs on sheetlike materials: designs reproduced on textiles, lace, and other fabrics; wallpaper; carpeting; floor tile; wrapping paper; and clothing.

Technical drawings: diagrams illustrating scientific or technical information in linear form such as architectural blueprints or mechanical drawings.

Text: textual material that accompanies pictorial, graphic, or sculptural works such as comic strips, greeting cards, games rules, commercial prints or labels, and maps.

Architectural works: designs of buildings, including the overall form as well as the arrangement and composition of spaces and elements of the design. NOTE: Any registration for the underlying architectural plans must be applied for on a separate Form VA, checking the box "Technical drawing."

3 SPACE 3: Creation and Publication

General Instructions: Do not confuse "creation" with "publication." Every application for copyright registration must state "the year in which creation of the work was completed." Give the date and nation of first publication only if the work has been published.

Creation: Under the statute, a work is "created" when it is fixed in a copy or phonorecord for the first time. Where a work has been prepared over a period of time, the part of the work existing in fixed form on a particular date constitutes the created work on that date. The date you give here should be the year in which the author completed the particular version for which registration is now being sought, even if other versions exist or if further changes or additions are planned.

Publication: The statute defines "publication" as "the distribution of copies or phonorecords of a work to the public by sale or other transfer of ownership, or by rental, lease, or lending"; a work is also "published" if there has been an "offering to distribute copies or phonorecords to a group of persons for purposes of further distribution, public performance, or public display." Give the full date (month, day, year) when, and the country where, publication first occurred. If first publication took place simultaneously in the United States and other countries, it is sufficient to state "U.S.A."

4 SPACE 4: Claimant(s)

Name(s) and Address(es) of Copyright Claimant(s): Give the name(s) and address(es) of the copyright claimant(s) in this work even if the claimant is the same as the author. Copyright in a work belongs initially to the author of the work (including, in the case of a work make for hire, the employer or other person for whom the work was prepared). The copyright claimant is either the author of the work or a person or organization to whom the copyright initially belonging to the author has been transferred.

Transfer: The statute provides that, if the copyright claimant is not the author, the application for registration must contain "a brief statement of how the claimant obtained ownership of the copyright." If any copyright claimant named in space 4 is not an author named in space 2, give a brief statement explaining how the claimant(s) obtained ownership of the copyright. Examples: "By written contract"; "Transfer of all rights by author"; "Assignment"; "By will." Do not attach transfer documents or other attachments or riders.

5 SPACE 5: Previous Registration

General Instructions: The questions in space 5 are intended to find out whether an earlier registration has been made for this work and, if so, whether

there is any basis for a new registration. As a rule, only one basic copyright registration can be made for the same version of a particular work.

Same Version: If this version is substantially the same as the work covered by a previous registration, a second registration is not generally possible unless: (1) the work has been registered in unpublished form and a second registration is now being sought to cover this first published edition; or (2) someone other than the author is identified as a copyright claimant in the earlier registration, and the author is now seeking registration in his or her own name. If either of these two exceptions apply, check the appropriate box and give the earlier registration number and date. Otherwise, do not submit Form VA; instead, write the Copyright Office for information about supplementary registration or recordation of transfers of copyright ownership.

Changed Version: If the work has been changed and you are now seeking registration to cover the additions or revisions, check the last box in space 5, give the earlier registration number and date, and complete both parts of space 6 in accordance with the instruction below.

Previous Registration Number and Date: If more than one previous registration has been made for the work, give the number and date of the latest registration.

6 SPACE 6: Derivative Work or Compilation

General Instructions: Complete space 6 if this work is a "changed version," "compilation," or "derivative work." and if it incorporates one or more earlier works that have already been published or registered for copyright, or that have fallen into the public domain. A "compilation" is defined as "a work formed by the collection and assembling of preexisting materials or of data that are selected, coordinated, or arranged in such a way that the resulting work as a whole constitutes an original work of authorship." A "derivative work" is "a work based on one or more preexisting works." Examples of derivative works include reproductions of works of art, sculptures based on drawings, lithographs based on paintings, maps based on previously published sources, or "any other form in which a work may be recast, transformed, or adapted." Derivative works also include works "consisting of editorial revisions, annotations, or other modifications" if these changes, as a whole, represent an original work of authorship.

Preexisting Material (space 6a): Complete this space and space 6b for derivative works. In this space identify the preexisting work that has been recast, transformed, or adapted. Examples of preexisting material might be "Grunewald Altarpiece" or "19th century quilt design." Do not complete this space for compilations.

Material Added to This Work (space 6b): Give a brief, general statement of the additional new material covered by the copyright claim for which registration is sought. In the case of a derivative work, identify this new material. Examples: "Adaptation of design and additional artistic work"; "Reproduction of painting by photolithography"; "Additional cartographic material"; "Compilation of photographs." If the work is a compilation, give a brief, general statement describing both the material that has been compiled and the compilation itself. Example: "Compilation of 19th century political cartoons."

7,8,9 SPACE 7,8,9: Fee, Correspondence, Certification, Return Address

Deposit Account: If you maintain a Deposit Account in the Copyright Office, identify it in space 7. Otherwise leave the space blank and send the fee of \$20 with your application and deposit.

Correspondence (space 7): This space should contain the name, address, area code, and telephone number of the person to be consulted if correspondence about this application becomes necessary.

Certification (space 8): The application cannot be accepted unless it bears the date and the handwritten signature of the author or other copyright claimant, or of the owner of exclusive right(s), or of the duly authorized agent of the author, claimant, or owner of exclusive right(s).

Address for Return of Certificate (space 9): The address box must be completed legibly since the certificate will be returned in a window envelope.

PRIVACY ACT ADVISORY STATEMENT Required by the Privacy Act of 1974 (P.L. 93 - 579)
The authority for requesting this information is title 17, U.S.C., secs. 409 and 410. Furnishing the requested information is voluntary. But if the information is not furnished, it may be necessary to delay or refuse registration and you may not be entitled to certain relief, remedies, and benefits provided in chapters 4 and 5 of title 17, U.S.C.

chapters 4 and 5 of title 17, U.S.C.
The principal uses of the requested information are the establishment and maintenance of a public record and the examination of the application for compliance with legal requirements.

Other routine uses include public inspection and copying, preparation of public indexes, preparation of public catalogs of copyright registrations, and preparation of search reports upon request.

NOTE: No other advisory statement will be given in connection with this application. Please keep this statement and refer to it if we communicate with you regarding this application.

REGISTRATION NUMBER

		VA	V	'AU
	Ē	FFECTIVE DATE	OF REGISTRATI	ON
			V	le .
	-	Month	Day	Year
DO NOT WRITE ABOVE THIS LINE. IF YOU NEED MORE SPACE, USE	A SEPARATE CO	ONTINUATION	SHEET.	
TITLE OF THIS WORK ▼	1	NATURE OF TI	HIS WORK ▼ s	See instructions
PREVIOUS OR ALTERNATIVE TITLES ▼				
PUBLICATION AS A CONTRIBUTION If this work was published as a contr collective work in which the contribution appeared. Title of Collective Work ▼	ribution to a periodic	cal, serial, or collec	ction, give informa	ation about the
If published in a periodical or serial give: Volume ▼ Number ▼	I.	ssue Date ▼	On Pa	ages ▼
NAME OF AUTHOR ▼		OATES OF BIR' Year Born ▼	TH AND DEAT Year Died	
Was this contribution to the work a "work made for hire"? □ Yes □ No AUTHOR'S NATIONALITY OR DOM Name of Country OR Citizen of Domiciled in		THE WORK	THOR'S CONT Yes No Yes No	RIBUTION TO If the answer to eithe of these questions is "Yes," see detailed instructions.
☐ 2-Dimensional artwork ☐ Photograph	□ Technical draw □ Text □ Architectural w	vork		
NAME OF AUTHOR ▼		DATES OF BIR Year Born ▼	TH AND DEAT Year Died	
Was this contribution to the work a "work made for hire"? ☐ Yes AUTHOR'S NATIONALITY OR DOM Name of Country OR Citizen of ☐		THE WORK Anonymous?	☐ Yes ☐ No	If the answer to either of these questions is "Yes," see detailed
☐ 2-Dimensional artwork ☐ Photograph ☐			Yes No	instructions.
YEAR IN WHICH CREATION OF THIS WORK WAS COMPLETED This information must be given must be given in all cases. DATE AND NATION Complete this information ONLY if this work has been published.	OF FIRST PUBL	ICATION OF T		
COPYRIGHT CLAIMANT(S) Name and address must be given even if the claim the author given in space 2. ▼		W 0115 DED	OSIT RECEIVE	D
TRANSFER If the claimant(s) named here in space 4 is (are) different from the auth space 2, give a brief statement of how the claimant(s) obtained ownership of the copy	nor(s) named in vright. ▼	TWO DEF	POSITS RECEIVED	

		EXAMINED BY	FORM VA
		CHECKED BY	_
		- CORDECROUNTIES	FOR
		CORRESPONDENCE	COPYRIGH
		103	OFFICE USE ONLY
			ONLY
		RE SPACE, USE A SEPARATE CONTINUATION SHEET.	
	REGISTRATION Has registration for this work, or for an earli If your answer is "Yes," why is another registration being sough	er version of this work, already been made in the Copyright Office? nt? (Check appropriate box) ▼	
	e first published edition of a work previously registered in unpub	[2017] 이 경기 경기 경기 경기 경기 경기 경기 보는 경기 보는 경기	-9
b. 🗆 This is th	e first application submitted by this author as copyright claimant		
	changed version of the work, as shown by space 6 on this applica		
If your answer	is "Yes," give: Previous Registration Number ▼	Year of Registration ▼	
DERIVATIV	VEWORK OR COMPILATION Complete both space 6a an	d (h fou a designativa graphy complete cally (h fou a comprilation	
a. Preexisting	Material Identify any preexisting work or works that this work is	s based on or incorporates. ▼	
		APRILIA LA CALLE AND	- Carlanta Na
			See instructions before completing
b. Material Ad	ded to This Work Give a brief, general statement of the material	that has been added to this work and in which copyright is claimed. ▼	this space.
			_
DEPOSIT A Name ▼	CCOUNT If the registration fee is to be charged to a Deposit Ac	count established in the Copyright Office, give name and number of Account. Account Number ▼	
Traine y		Account Number V	
			_
CORRESPO	NDENCE Give name and address to which correspondence ab	out this application should be sent. Name/Address/Apt/City/State/ZIP▼	
			_
			Be sure to
			give your
	Area Code and Telephone Number		daytime phor ◀ number
CERTIFICA	TION* I, the undersigned, hereby certify that I am the		
check only one			0
author			- 7
☐ other copyri	ght claimant		
owner of ex	clusive right(s)		
authorized a	ngent of	Wa) A	
	Name of author of other copyright claimant, or owner or exclusive right	(15) A	
of the work ide	entified in this application and that the statements made		
	pplication are correct to the best of my knowledge.		_
Typed or prin	ted name and date $lacktriangle$ If this application gives a date of publicatio	n in space 3, do not sign and submit it before that date.	
		Date	_
F F	Handwritten signature (X) ▼		
		YOU MUST:	
Mail certificate	Name ▼	Complete all necessary spaces Sign your application in space 8	
to:		SEND ALL 3 ELEMENTS IN THE SAME PACKAGE:	-
Certificate	Number/Street/Apt ▼	Application form Nonrefundable \$20 filing fee	
will be		in check or money order payable to Register of Copyright	s
mailed in	City/State/ZIP ▼	3. Deposit material MAIL TO:	
window envelope	The state of the s	Register of Copyrights Library of Congress	
	Secretary and the secretary an	Washington D.C. 20559-6000	

17 U.S.C. § 506(e): Any person who knowingly makes a false representation of a material fact in the application for copyright registration provided for by section 409, or in any written statement filled in connection with the application, shall be fined not more than \$2,500.

SECTION II ART

CHAPTER 4 INVENTORY

Master inventory

Keep a record of each work you start. Give each new piece a code number as you begin its production. Perhaps 010599, standing for January 1, the fifth day in 1999.

Historical documentation of originals

Use this form to give each piece you create its own historical data sheet.

Historical documentation of prints

Each print, limited edition, card edition, etc. should have its own historical data sheet.

Artwork out

Keep a record of each original artwork that leaves your studio. This record will often match your consignment records. You should also keep track of rentals, exhibitions, loans—any circumstance when your artwork leaves your possession. Have a signed piece of paper confirming each piece that is taken from your studio.

Slide reference sheet

This sheet corresponds to the 20 slots of a slide sleeve. Put the title of the artwork in each slot. It also serves as a record of where slides were sent. Attach a copy of this to each slide sleeve you send out. Keep a photocopy for your own records.

Slides/photos/transparencies/portfolios out

Keep track of where you send portfolios, slides and transparencies. Follow up with calls if you don't hear back.

Competition record

Keep track of competitions you enter so you can 1) see what you might be doing wrong if you are not being accepted and 2) add awards to your resumé.

Exhibitions/competitions

This sheet provides you with a comprehensive overview of the exhibitions and competitions you've entered. Keeping this information up-to-date allows you to update your resumé easily.

Item request record

Use this when you send away for a prospectus, information on supplies, or any item you request by mail or telephone.

MASTER INVENTORY

ode#_	Title	Med	Size	Started	Finish'd	Sold	Price	Location
					14 11 11 11			
					28.7			
								2 1
			- 					
			- 200 kg	i i				7 687 4
	1.00			j j		104		
				1		- 7 77		7
			P 1			7		7
						0.00		
							1000	
			1 132			1	1.5	
	*							
-								

HISTORICAL DOCUMENTATION OF ORIGINALS

Date begun				
		Date completed	Hours to com	plete
Price/frame	ed	Price/unframed	Other costs	e en telle to
Size/frame	d	Size/unframed		
Medium				
Colors	. Jan			
Design desc	cription			photo of
Inspiration	6 ti - 1		IIIIa	ge here
Techniques	used in execution			
Materials us	sed in framing			
Recommen	dations for care			
		10 pt 120 120 120 120 120 120 120 120 120 120		
		EVIDITION LUCT	ORV	
		EXHIBITION HISTO	ORY	
Date	Location	EXHIBITION HISTO	ORY	Date returned
Date	Location	EXHIBITION HISTO	ORY	Date returned
Date	Location	EXHIBITION HISTO	ORY	Date returned
Date	Location	EXHIBITION HISTO	ORY	Date returned
Date	Location			Date returned
Date	Location	EXHIBITION HISTO		Date returned
Date Date sold	Location			Date returned
	Location	PURCHASE HISTO		Date returned
Date sold		PURCHASE HISTO	DRY	Date returned

HISTORICAL DOCUMENTATION OF PRINTS

Inventory #	Title		
Date printed	Quantity printed	Signed copies	
Price/framed	Price/unframed		
Printing info			
Y.			2
Other info			
		Transfer de la company de la c	- inde

		PURCH	ASERS		
1.					
2.					
3.					
4.					
5.			360		
6.					2
7.					
8.			-		,
9.					
10.					
11.		1, 2		, · // = .	*
12.	.23	Es a			
13.	14.7				
14.					

ARTWORK OUT

Date	Code #	Title	Location	Returned	Result
			702		
					0.2
		· · · · · · · · · · · · · · ·			1 0 15 1 1 1 1 1 1 1 1 1 1 1 1 1 1 1 1 1
					d.
					7
					1 1
					1 ^N
					15 M 1 1 1 1 1 1 1 1 1 1 1 1 1 1 1 1 1 1
	and the second				
					7

SLIDE REFERENCE SHEET Sent to _____on___ Art Office by Smith & Viders

SLIDES/PHOTOS/TRANSPARENCIES/PORTFOLIOS OUT

Date sent	Location	Item	SASE	Returned	Result
					7-1-1
	1				
					(°)
	1 , 41 r	e1.			
7 I					
, ,			1		
				a.	
				14	
en ()				7,	
er a					

COMPETITION RECORD

Competition name		Closing date Fee
Date applied	Juried/non-juried	Accepted/rejected
Artwork sent		
Juror name(s)		
1st Prize	2nd Prize	3rd Prize
Comments		The second secon

Competition name		Closing date Fee
Date applied	Juried/non-juried	Accepted/rejected
Artwork sent		
Juror name(s)		
1st Prize	2nd Prize	3rd Prize
Comments		

Competition name		Closing date Fee
Date applied	Juried/non-juried	Accepted/rejected
Artwork sent		
Juror name(s)		
1st Prize	2nd Prize	3rd Prize
Comments		

EXHIBITIONS/COMPETITIONS

				1	
-		1			
	1		200		
	-			•	- 18 m
			PS		
	-				
1 1		1 70 1		-	
					-
. 7					
6 1			Tu P		
		- 102			
			-	I and I	
					I pp
					n

ITEM REQUEST RECORD

ite	Item requested	Address	Telephone	Date rec'
1,7				
-				
	* '			
	4			

SECTION II

CHAPTER 5 CUSTOMERS

Target market chart

Fill this out and study your answers to gain insight regarding where to concentrate your marketing efforts.

Consumer profile

Another form similar to the previous one. Each will help decipher your target market.

Customer/client record

Keep a record for each client as well as each potential client. File these alphabetically in your three-ring binder. When one of these people calls, turn to his/her page so you'll remember who they are, what they need, color preferences, etc.

Phone-zone sheet

Use this form to keep track of phone calls you make to prospective and current clients. It will help you remember to follow up. Keep these records at least five years. File this with the matching *Customer/client record*.

Mailing list sign-up sheet

Put this out at your next open studio or show for interested parties to sign. Add these names to your inhouse mailing list, sending to them at least twice a year, perhaps a postcard, an invitation to an exhibition, or a Christmas card with a photo of your latest creation.

TARGET MARKET CHART

□Men □Women □ Children □ All	Education level:
Marital status:	How are they like me?
Ethnic background:	How are they different?
Age group:	Values/tastes:
Religion:	What do they read?
Living environment:	Impression I want to make?
Income level:	Where do they 'hang out'?
How do they spend their leisure time?	
Where or how am I most likely to get their at	tention?
Potential clients in order of priority:	
What are their reasons for huning my art?	
What are their reasons for buying my art?	
What organizations do they belong to?	
Specific region of the country to sell to:	
openie region of the country to sen to.	
Describe exactly what I am selling:	
Define more specifically my target market:	
Features of my artwork:	
Benefits to buyer. Can I offer something more, s	comething different, something better than my competitors?
Who is my competition?	
What can I learn from them?	
Experience, authority, expertise—why someon	ne would trust me:
How will buying my artwork make the custor	ner's life better?
How can people have for their purchase (and:	it card shock torms\2 \Mill thistief
11011 can people pay for their purchase (credi	it card, check, terms)? Will this satisfy my target market?
Am I able to produce enough original pieces	for potential buyers in my target market?
Are there any legal considerations in selling n	ny product to this (or any other) market?

CUSTOMER PROFILE

DEMOGRAPHICS	
Mostly male/female	
Age	
Education level	
Income level	
Single/married/divorced	
Children/grandchildren	
Occupation/profession	
Religion	
Ethnic background	
GEOGRAPHICS	
Lives in city/suburb/rural	
Rents/owns/type of building	
Type of living environment	CONTRACTOR OF THE PROPERTY OF
Groups/assns/clubs	
Hobbies/leisure time activities	
Shops where: stores/catalogs	
Shops how: cash/credit	
PSYCHOGRAPHICS	
Lifestyle	
Perceived social status	
Knowledge of art	
Favorite magazine	
Personal attitudes	
Personal values	
Special beliefs	
Unique tastes	A series of the
How they are like me	
How they are different from me	
建大型的影响。	

(CUSTON	MER/CLI	ENT RECORE	
Name				
Address				
Work phone		Home phone	9	Age
Referred by				
	BAC	KGROUND IN	FORMATION	
Single/married/divo	orced	Spouse's nar	ne and age	
Children and ages			1 1 1 1 1 1 1 1 1 1 1 1 1 1 1 1 1 1 1	
Pets		En .		
Occupation			Marie and the second	
Education/income	level		4/8	
Type of furnishing/h	nome style			
		ART PREFER	ENCES	
Subject matter		Colors		
Style/type of work		Size/me	dium preferred	
Needs/wants		- 47		
Intended use				
THE CONTRACT OF THE PARTY	IMP	RESSIONS AND	COMMENTS	
Last contact date by	y phone			
Last mailing				
Needs information	on			Transport (fig
Other follow-up ne	eds		4	
14		PURCHA	SES	
Date Price	Size	Medium	Title/Description	Use
100				
			to the same of the	

PHONE-ZONE SHEET

Name					10.1	
Address						
City/State/Zip						
Phone						
Fax						-
Personal details				¥ 1		
r <u>- 2 m - 2 m - 1 m</u>	-					2
Art interest						

Date	Time	Phone/Letter/Call	Notes	Follow-up
\ \ \				
				7,3
	2			
			<i>(</i>	
			glaria manganan	
1 1		- 1		

MAILING LIST SIGN-UP SHEET

Name	Address	City	State	Zip	Telephone
1.					
2.					
3.					3
4.			1 -		
5.					- "
6.					
7.					
8.					
9.					
10.					
11.					
12.					
13.		789		6	
14.					
15.					
16.	0 00 * 0				
17.	7		\(\frac{1}{2}\)		
18					
19.	- 10 op - 70 o				
20.		- 1			7 2 .
21.			-		
22.					

SECTION III MARKETING

CHAPTER 6 PLANS

Sample marketing plan

This sample will help you think about what your personal plan could contain.

Marketing plan

You should re-analyze this every six months. Keep copies of your old ones in your handy three-ring binder so you can see how you've grown and changed in your thinking.

Five-year goals

Take the previous form, *Marketing plan*, and break it down into a practical five-year plan. You will need to work and rework this as time goes by. Keep copies so you can study how your intentions have changed.

Twelve-month goals

Break down your Five-year goals into smaller goals on this twelve-month plan. Be specific.

Project planner

This form will keep each project moving at a good pace.

Project progress chart

Keep each goal moving, focused and organized by using this form.

Monthly project status

See how your goals are progressing on a monthly time-frame with this form.

Show planning calendar

Careful planning makes every show a success. Use this calendar with a group of artists working together, or improvise for your own solo show.

Twelve-month show planning calendar

This gives you a precise time-line for achieving a successfully promoted show.

Exhibit expense planner

Each show needs a budget and spending plan; otherwise you will tend to overspend.

Publicity planning chart

An overall chart to keep track of where you've tried to get publicity and how you've been successful.

Checklist for a juried show

Applying to different shows shouldn't be done in a haphazard manner. Using this form will insure that each entry form you fill out is followed up.

Print planning calendar

All self-published artists should use this type of form to keep track of print projects.

SAMPLE MARKETING PLAN

To find the best niche/subject matter/area in which I can n	nake the most money
Long-range objective	
To be in 10 galleries within the next five years	
To get into print within one year	
	2
Specific objective	
Find my most sellable image	
Current strategies	
Enter at least two juried shows	
Enter at least three art/craft shows (or plan an open studio)
Promotional materials	
Promotional materials New business cards	
New business cards	
New business cards Update resumé	
New business cards Update resumé	
New business cards Update resumé	
New business cards Update resumé Take photographs of current work	
New business cards Update resumé Take photographs of current work Future strategy ideas	
New business cards Update resumé Take photographs of current work Future strategy ideas Pre-holiday group show	
New business cards Update resumé Take photographs of current work Future strategy ideas Pre-holiday group show	
New business cards Update resumé Take photographs of current work Future strategy ideas Pre-holiday group show Teach a class	

MARKETING PLAN General goal Long-range objective **Specific objective Current strategies Promotional materials Future strategy ideas** Future promotional materials needed

FIVE-YEAR GOALS

	5-YEAR GOALS	
1.		
2.		
3.		
4.		A SALEJE STORE
COLD STREET	4-YEAR GOALS	
1.		
2.		The second of th
3.		
4.		
	3-YEAR GOALS	
1.		
2.		
3.		
4.		
	2-YEAR GOALS	
1.		
2.		
3.		. coga Talangan Sa
4.		grand the state of

TWELVE-MONTH GOALS 1. 2. 3. 4. **STEPS TO REACH GOAL 1** b. c. d. **STEPS TO REACH GOAL 2** a. b. C. d. **STEPS TO REACH GOAL 3** a. b. c. d. STEPS TO REACH GOAL 4 a. b. c. d.

PROJECT PLANNER

Project title		Date	
Goal of project			× =1
Target audience	5	Target date	
Pertinent facts/comments			
	4486 - 1867 1966 - 1868 - 1868 18		
Plan of action		i i i i i i i i i i i i i i i i i i i	56
PEOPLE TO CONTACT	TELEPHONE/LET	TER FOLLOW-U	JP
PEOPLE TO CONTACT	TELEPHONE/LET	TER FOLLOW-U	JP .
PEOPLE TO CONTACT	TELEPHONE/LET	TER FOLLOW-U	JP .
PEOPLE TO CONTACT	TELEPHONE/LET	TER FOLLOW-U	JP .
PEOPLE TO CONTACT	TELEPHONE/LET	TER FOLLOW-U	JP
PEOPLE TO CONTACT	TELEPHONE/LET	FOLLOW-U	JP.
PEOPLE TO CONTACT	TELEPHONE/LET	TER FOLLOW-U	JP
PEOPLE TO CONTACT			JP
PEOPLE TO CONTACT	PROJECT OUTCOM		JP .
PEOPLE TO CONTACT			JP
PEOPLE TO CONTACT			JP

PROJECT PROGRESS CHART

D				
Project:		1 1 1 1 1 1 1 1 1 1 1 1 1 1 1 1 1 1 1		

eople to contact	Possible action	Follow-up	Deadlines
4 ,			
	1		
	, 47		
	RESULTS		

MONTHLY PROJECT STATUS

PROJECT	Actively being wo	Ou pack puruer	Completed/file clo	Abandoned
\$40.	A		sa .	

SHOW PLANNING CALENDAR

	Assigned to	Completed by	Done
Start a group			
Establish a leader		Page 200	
Decide where to exhibit			
Pick show title	- <u>1</u>	1 10 1	
Pieces per artist			- X - 24 - 1
Expenses per artist			
Job assignments			
Confirm place			
Confirm date		10 mm	
Get photos			
Design invitations			
Prepare mailing list		ty v	
Prepare literature			
Send out PR	, i	200	
Address invitations	.s /v /	i (19	
Find display stands		1 1 1 1 1 1 1 1 1 1 1 1 1 1 1 1 1 1 1	- 1
Label work		4,	
Price work			
Make inventory lists		1 公益等	- L.
Plan refreshments			
Get extra help			
Develop a hanging plan			
Set up sales area			
Bring extra tools	i i		

Art Office by Smith & Viders

TWELVE-MONTH SHOW PLANNER

	Date to be done	Duties	Done
12 MONTHS PRIOR			
Locate a place			
10 MONTHS PRIOR			
Decide on theme			1000
Plan budget			
Plan advertising		. 6	
8 MONTHS PRIOR			
Create invitation list			
6 MONTHS PRIOR			
Design invitations			100
Select B&W photo for PR		* * * * * * * * * * * * * * * * * * * *	
4 MONTHS PRIOR		y, u	
Frame pieces			
3 MONTHS PRIOR			
Print invitations			20
Mail PR to monthly pubs			
Find salespersons	3		
2 MONTHS PRIOR			
Address invitations			
1 MONTH PRIOR	5	- 4,*	
Mail PR to semimonthly pubs			
Mail invitations			
Call current clients			
Plan refreshments, decorations			
2 WEEKS PRIOR			
Call press/local PR			75
3 DAYS PRIOR			
Hang work			* 16 f= 2
DAY OF			
Arrive early	ra Berli		
FOLLOW-UP		=	4.1
Dismantle			1 7 7
Write thank-you notes			

EXHIBIT EXPENSE PLANNER

Name of show		Dates/hours of	show
Sponsor			
Number of pieces needed		4 = 1 4	
Shipping/delivery instructions		. Ex.	, es
	PREPARAT	ION	
Forms			
Packing			
Travel arrangements			
			<u> </u>
	EXPENSI	E S	
Entry fee	Framing		Crating
Travel	Food		Lodging
Advertising	Brochures		Insurance
Other			
	RECORD OF	SALES	经验证的 证据
Number of originals shown		Number of p	orints sold
Title		Price	
		* **	
Number of prints shown		Number of p	orints sold
Title		Price	
	<u> </u>		

PUBLICITY PLANNING CHART

	Idea/event	Materials needed	Deadlines
Daily newspapers			
			But the section
		, Marin (1900)	
Weekly newspapers	77/6		
	1000		1)
Local publications			
			1
Local magazines			
		31 ·	
n. P			
Radio			
	, , , , , , , , , , , , , , , , , , ,	.15	7 2 2 1 1 1 1 1 1 1 1 1 1 1 1 1 1 1 1 1
TV			* * * * * * * * * * * * * * * * * * * *
I V			
			W
	NOTES		
表的 对 使用的数据的。1982年2月	NOTES		
100	2.5.		

CHECKLIST FOR A JURIED SHOW

SHOW NAME				
------------------	--	--	--	--

(1) (1) (1) (1) (1) (1) (1) (1) (1) (1)	Needs to be done	In progress	Done
PREP WORK			
Visit show the year before			
Decide to enter	All hy		
Call/get on mailing list		p ⁴ r v ja	
APPLYING		-	
Decide which slides to send			7
Label each slide correctly	a 9 G L 3		
IF ACCEPTED			
Add show date to calendar			7 X
Decide on framing			
Arrange for delivery		Charles Ingl	
Visit show			8
	(6) (7) (1)		
AFTER SHOW		di 188 j	
Arrange to pick up unsold work			2
Keep list of awards won			

Art Office by Smith & Viders

PRINT PLANNING CALENDAR

Name of print		
Proposed size and quantity		

	Pate Activity	Notes	Done
6 months	Plan painting with purpose of print		
	sales in mind. Select appropriate		
	subject matter.		
5 months	Test-market finished painting.		
	Develop printing, framing and		
	promotional budgets.		
4 months	Place printing order with printer.	*	
	Order adequate promo flyers/		
	postcards. Develop order forms.		
3 months	Arrange for framing and		
	presentation of prints.		
2 months	Get mailing list in order.		
1 month	Mail out promo pieces.		
	Check on framing.		
Follow-up	Stay in touch with people		10
	who purchased and those who		
	expressed interest.		

SECTION III MARKETING

CHAPTER 7 SAMPLE LETTERS

Composing a letter takes time and intentional thought. A letter writer needs to put him/herself in the position of the recipient. What does the recipient want to know, need help with, etc.? The following sample letters are to get your creative writing juices circulating. Copy them as closely as you like, but add your own style, keeping your letter brief and to one page. Purchase eye-catching paper, design an interesting logo, and sign your name in a colored ink to add your personal touch! Keep each letter to one page.

Introduction letter

This alone gives the reader a certain feeling about the establishment of the artist. It is brief (basically one sentence of reading) and thus enticing most receivers to read it. Once read, a reader will be impressed by this artist's reputation. Your visuals are the most important factor of your package.

Query to gallery

A simple, short letter is most effective. Let your artwork do the talking.

Application request

If you have a computer, this letter can easily be adapted to your personal needs.

Sample issue request

Educate yourself by reviewing a variety of publications. Often you can receive a complimentary copy of a publication with this type of inquiry.

Response to inquiry

Keep these people on your mailing list. It takes three or more "hits" of seeing your artwork before they'll remember you.

Query to book publisher

Query to art publisher

It always helps if you've called first to verify this is a qualified publisher for the type of work you have.

Query to magazine editor

Query to interior designer

Confirmation of sale

This letter is sent after a meeting and an idea (sale, exhibit, etc.) have been agreed upon verbally. Such a letter is good legal tender in case something goes awry. Keep confirmation short and to the point.

Confirmation of exhibition

This is only a confirmation of what was agreed to verbally. You will want to have a signed *Exhibition Agreement* also.

Thank you for purchase

A thank-you is always remembered!

Press release

For complete details on press releases, review Art Marketing 101.

INTRODUCTION LETTER

July 23, 1999

Evelyn Ronder 17746 Manzanita Ln Sacramento, CA 95817

Dear Ms. Ronder,

It was nice speaking with you today. I am enclosing the following per our conversation:

- Resumé
- Magazine articles
- Slides
- Various press releases

Thank you for considering being part of the group of architects, designers and serious art collectors presently making Katz an international force in the contemporary artworld.

Please review the enclosed slides and background materials and return them in the SASE provided, unless, of course, keeping them on file is to our mutual advantage.

Sincerely,

Shirley Katz

Enclosure

QUERY TO GALLERY

July 23, 1999

Sanders Gallery Evelyn Ronder 17746 Manzanita Ln Sacramento, CA 95817

Dear Ms. Ronder,

Your gallery came to my attention during a recent visit to your city. I am requesting the opportunity to be represented by Sanders Gallery.

Please find enclosed the following:

- Resumé, noting galleries and exhibits that have brought me attention
- Magazine articles
- Slides
- Various press coverage which I have received due to the great interest in my work

In addition to offering original work, Katz Art has limited and open editions available. I am also agreeable to taking on custom commissions that are within my range of work.

Please review the enclosed slides and background materials and return them in the SASE provided, unless, of course, keeping them on file is to our mutual advantage.

I will contact you next week to confirm that you have received this package.

Sincerely,

Shirley Katz

Enclosure

APPLICATION REQUEST

July 23, 1999

Sacramento Arts Commission 17746 Manzanita Ln Sacramento, CA 95817

To whom it may concern:

Please send me information and an application to the City Art Program that is funded by the Sacramento Arts Commission. I would also appreciate receiving any brochures your commission might have to familiarize myself with your association.

I have enclosed a SASE for convenience. Thank you for your time and consideration.

Sincerely,

Shirley Katz

Enclosure

SAMPLE ISSUE REQUEST

July 23, 1999

Art Now Magazine Ad Department 17746 Manzanita Ln Sacramento, CA 95817

Dear People:

Please send me a sample of your media package, including:

- Rate card (for display and classified)
- Notes on upcoming special editions
- · Sample issue
- Circulation figures

If you offer special rates to new advertisers, please include that information.

Sincerely,

Shirley Katz

Art Office by Smith & Viders

RESPONSE TO INQUIRY

July 23, 1999

Sanders Gallery Evelyn Ronder 17746 Manzanita Ln Sacramento, CA 95817

Dear Ms. Ronder,

Thank you so much for your inquiry about my new print *Abiding*. I am enclosing my resumé and note cards which show this print, as well as a brochure that references other available prints.

A retail price list is also enclosed. Dealer discounts of 50% for unframed prints and 40% for framed prints, plus packaging and shipping, are available.

If you have any questions or would like to place an order, please call me at the number below.

Sincerely,

Shirley Katz

Enclosure

P.S. Original works are also available!

QUERY TO BOOK PUBLISHER

July 23, 1999

Art Resource Ltd Evelyn Ronder 17746 Manzanita Ln Sacramento, CA 95817

Dear Ms. Ronder,

Please find enclosed slides of my artwork. All these pieces are available for publication upon approval. Per my enclosed resumé, please note that I have done a number of illustrations for children's books.

I hope you will enjoy these pieces and find them unusual and motivating. In their original form, they are quite large—5x7 feet! Patrons continue to add originals to their collections.

Enclosed is a SASE for returning the slides and background materials, unless, of course, keeping them on file is to our mutual advantage.

Sincerely,

Shirley Katz

Enclosure

QUERY TO ART PUBLISHER

July 23, 1999

Art Resource Ltd Evelyn Ronder 17746 Manzanita Ln Sacramento, CA 95817

Dear Ms. Ronder,

Please find enclosed slides of my artwork which I would like you to consider for the print market. All these pieces are available for publishing upon approval.

As you can see from my resumé, I have done quite well working with interior designers. My work is well received by the public. In their original form, my pieces are quite large—5x7 feet! Patrons continue to add originals to their collections.

Enclosed is a SASE for returning the slides and background materials, unless, of course, keeping them on file is to our mutual advantage.

Sincerely,

Shirley Katz

Enclosure

QUERY TO MAGAZINE EDITOR

July 23, 1999

American Artist Magazine Stephen Doherty 17746 Manzanita Ln Sacramento, CA 95817

Dear Mr. Doherty,

I believe your readers would be interested in a profile of my art because it is an excellent example of creating art with an ancient medium—egg tempera, a medium usually associated with medieval painters. Articles on this method garner reader attention because it is unusual.

Enclosed are three photographs of the artwork and a short explanation of how and why it was created. I've also included my resumé and other select clippings to show how well my work reproduces in print.

I've enclosed a SASE for your convenience to return my materials should you not use them at this time.

Please call or fax me if you have questions or wish to see additional materials.

Sincerely,

Shirley Katz

Enclosure

QUERY TO INTERIOR DESIGNER

July 23, 1999

Interiors Inc Evelyn Ronder 17746 Manzanita Ln Sacramento, CA 95817

Dear Ms. Ronder,

Thank you for talking with me on the phone last week. Please find enclosed the following:

- Resumé
- Magazine articles
- Slides
- · Various press releases

I hope you will become part of the group of architects, designers and serious art collectors presently making my work an international force in the contemporary artworld. Clients love the large-scale pieces (5x7 feet). To decorate around these lively pieces is a joy.

I look forward to working with you in the future. I will call you next week to make sure you have received this package.

Sincerely,

Shirley Katz

CONFIRMATION OF SALE

July 23, 1999

Stanley Corp Evelyn Ronder 17746 Manzanita Ln Sacramento, CA 95817

Dear Ms. Ronder,

This letter is to confirm our transaction of July 22, 1999 at my studio, in which you agreed to purchase my original oil painting titled *Masterpiece*, measuring 5x7 feet, with a wooden frame created by me, for the sum of \$2500 (exclusive of tax or shipping).

As agreed, I shall hold the painting at my studio until August 10, 1999—the date agreed upon for complete payment and transfer of the painting to Stanley Corp. At that time we shall execute a complete bill of sale.

I look forward to our next meeting.

Sincerely,

Shirley Katz

Art Office by Smith & Viders

CONFIRMATION OF EXHIBITION

July 23, 1999

Melvin Gallery Evelyn Ronder 17746 Manzanita Ln Sacramento, CA 95817

Dear Ms. Ronder,

I am pleased that you will be showing my artwork in a four-week, one-person show in January 2000. As we discussed when we met at your office, I will be given the front three rooms in your gallery, which equals 300 square feet of wall space. You will receive the work, hand delivered, by December 26, 1999.

I am delighted that you will have an opening celebration of my exhibition for critics and patrons. As requested, I am enclosing a mailing list for you to incorporate into your existing list of 1500 patrons. I understand that you will be designing, mailing and paying for the invitations.

I will be responsible for insuring the works up to the time they arrive at your gallery. From that point, they will be covered by your insurance. I will pick up the unsold pieces between February 1 and 6, 2000.

Pursuant to our agreement, you will receive a forty percent (40%) commission on all works sold during the exhibition. A consignment agreement will accompany my work brought to you in December, with specific titles, costs, mediums, sizes, etc.

Sincerely,

Shirley Katz

THANK YOU FOR PURCHASE

July 23, 1999

Gene Tyler 17746 Manzanita Ln Sacramento, CA 95817

Dear Mr. Tyler,

I appreciate your interest in my artwork. I am shipping *Blue Heronry* to you today via Federal Express COD, per your request.

The price of this piece, as we agreed, is \$804.38 which includes the California sales tax. I have added on \$45 for Federal Express shipping to total \$849.38.

I like to inform my clients of the terms of sale as follows:

- · All works are originals, unless otherwise indicated.
- All works are certified to be free from all defects due to faulty craftsmanship or faulty materials for a period of twelve months from date of sale. If flaws shall appear during this time, repairs shall be made by me.
- · Copyright privileges are retained by artist.

Sincerely,

Shirley Katz

P.S. I am enclosing an invitation to my Spring Show. As it is a black tie, champagne reception, please present this invitation at the door for admission for yourself and a guest. I hope to see you there! If you'd like to bring another couple, I'll be glad to forward another invitation.

13672 Woodridge Ln, Westheimer, MA 02373 (232) 676 8732 (232) 676 4454 Fax

Art Office by Smith & Viders

PRESS PRELEASE

FOR IMMEDIATE RELEASE

Contact: Shirley Katz 232/676-8732

LOCAL ARTIST TO HOLD ONE-PERSON SHOW

Shirley Katz will exhibit 12 of her unique egg tempera paintings in a one-person show March 18-25, 1999 at Kramer's Gallery, 1854 First Avenue, Boston, MA. An opening reception honoring her will be held March 19, from 7 - 9 P.M., and is free and open to the public.

Katz's technical mastery of this ancient medium—egg tempera—has gained her national recognition. She won the Best of Show Award in the prestigious Masters Show in New York City in 1998, and her painting *Santa's Angels* received the Outstanding Painting Award for technical merit at the Professional Painter's Show in Dallas, Texas that same year. Her paintings are in the collections of prominent citizens nationwide.

Egg tempera, a medium usually associated with medieval and early Renaissance painters, is essentially pure pigment suspended in a binder of egg yolk. It is an opaque paint which dries very quickly, meaning one layer of color must be 'cross-hatched' over another. This helps to create the glow that egg tempera gives to artworks, making it a perfect medium for realistic scenes.

#

Biography and photographs of Shirley Katz and her award-winning works sent upon request.

SECTION III MARKETING

CHAPTER 8 SALES

Pricing worksheet for originals

This form helps you calculate what your prices should be. Raise your prices slowly as you sell more and as time passes.

Pricing worksheet for prints

Use this form to calculate costs of printing *before* you print, so you will know how much your prints will have to sell for. Guessing at pricing doesn't work!

Certificate of title

This is a form you give to buyers of your original artwork as an added touch of professionalism. Put your logo in the blank space at the top.

Certificate of authenticity

When you are selling a limited edition print, you want to insure your client that it is just that. Adhere this to the back of the frame, so it's never misplaced.

Bill of sale

This form should be used when completing a sale to a private buyer (contrary to a *Gallery Agreement* in Chapter 3). This outlines clearly and simply their rights and yours.

Provenance

Provide a buyer with one of these at the time of sale. You are explaining the history of your piece to the buyer. Remind him/her to give it to anyone that inherits or buys the piece at a later time.

Price list

You can use this form for a show, in your mailings or when approaching galleries. Update it often. Date it so potential buyers know they have a current list.

PRICING WORKSHEET FOR ORIGINALS

Title of work			Code #	
Date started Date completed	Total hou	ırs	Hourly rate	Salary
Materials used in execution of piece (brand na	me, type	of pai	nt, paper, fiber, me	etals, etc.)
Cost \$				
Materials used in presentation (base, backing,	frame, m	at, pro	otective covering, I	nanging rods)
				Argengos
Cost \$		-25		λ
			81 8g	
Overhead	*	\$		
Salary (hourly rate x total hours)	В	\$		
Profit (10% of above two items)	С	\$		
Sub-total (* $+$ B $+$ C)	D	\$		
Commission (equal to sub-total)	Е	\$		
Retail price/unframed (D + E)	F	\$		
Frame, mat, etc.	G	\$		
Retail price/framed (F + G)	Н	\$	The African	

*TO CALCULATE OVERHEAD

Take total business expenses for the year such as dues, education, utilities, publications, postage, etc. but not including material costs. Divide this total by 12 to come up with a monthly overhead figure. For example, \$3600 total expenses for the year, divided by 12, would equal \$300 per month average overhead. Divide this monthly figure by average number of original pieces completed in month to arrive at overhead percentage cost.

PRICING WORKSHEET FOR PRINTS

Date printed	Quantity print	ed	
Printer's name/address			
Method of printing used	, g =		
ल ^{कार} कुंब वरिन्द्रको ।			
	* Kee		
Price to print (per unit)	. = 1	Α	\$
Royalty (10% of A)	2	В	\$
Profit (10% of A + B		С	\$ **
Sub-total (A + B + C)	D	\$
Commission (equal to D)	12 J	Е	\$
Retail price/unframed (D + E)		F	\$
Signed piece additional cost		G	\$ Sergi [®] U.S.
Retail price/unframed/signed (F + G)	8 10 ₃	Н	\$
Frame, mat, etc. (actual cost)		I	\$ en gara (1965 ya
Retail price/framed (F + I)		J	\$
Retail price/framed/signed (G + J)			\$

Art Office by Smith & Viders

CERTIFICATE OF TITLE

I,	, am the creator of the
artwork entitled	
, size of, sub	
I created said artwork on	
I certify the above noted artwork to be an orated by me, the artist, I am transf	•
Name	
Address	
Signature of new owner	
Signature of artist	
Date	

CERTIFICATE OF AUTHENTICITY

		nave been t	destroyed.	
Artist			_	
Addross				
Address			-	
Title		30 ve ³⁴ 10 o	1	
Medium				
		ď	-	
Dimensions			-	
Year printed			_	
Date of sale	•			
Signature of artist				

BILL OF SALE Sold to Address_____ Phone _____ **DESCRIPTION OF WORK** Title Date completed Size Medium Framing Miscellaneous **TERMS OF SALE** Purchase price Sales tax Shipping Total ☐ Cash/check ☐ Credit card • Resale or transfer of work requires that I be informed of the new owner and the price of sale. Should the price be more than \$1000 over the original price stated herein, according to California state law, 10% of amount over original price shall be given to artist by seller. • Artist shall have right to photograph piece, if necessary, for publicity or reproduction purposes. • Artist shall have right to include artwork in retrospective show for a maximum of 3 months. • If artwork is rented out by purchaser, artist will receive 25% of rental income. Artwork cannot be exhibited in public without written approval of artist. Artist's signature Date **Address** Phone Received in good condition: Purchaser's signature Date Address

REPRODUCTION RIGHTS RESERVED BY ARTIST

Phone

PROVENANCE

Artist's name	1	Place image of	
Title		artwork here	
Medium			
Dimensions			
Year completed			
This artwork was completed b	by the artist noted abo	eve and was signed by the artist.	
This artwork was acquired by	,	in .	
,,,,,,,,,,,,,,,,,,,,,,,,,,,,,,,,,,,,,,,	(Seller)	in (Year of purchase)	
Name of larmon			
Name of buyer			
Name of buyer Address of buyer			
Name of buyer Address of buyer Phone number			
Name of buyer Address of buyer Phone number			
Name of buyer Address of buyer			
Name of buyer Address of buyer Phone number on, for the s	sum of \$		
Name of buyer Address of buyer Phone number on, for the s	sum of \$		
Name of buyer Address of buyer Phone number on, for the s	sum of \$		
Address of buyer Phone number on, for the s (sale date)	sum of \$	rice)	
Address of buyer Phone number on, for the s (sale date)	sum of \$	rice)	

Art Office by Smith & Viders

PRICE LIST

Date		
LINTO		
1 Jaie		

所以在这是被整合的	ORI	GINALS		
Title	Size	Medium	Cost/unframed	Cost/framed
1905 d Starcher Level				
				and a compare the
				The state of the s
				ención de c
				17 65
	DI	RINTS		
Title				
Title	Size	Medium	Cost/unframed	Cost/frameo
	<u> </u>			
	, 46, 11, 1	at Might and the second	A STATE OF THE STA	学表 40 4
				A 21 31 12
	1			
A				
	О	THER		
Title	Size	Medium	Cost/unframed	Cost/framed
21				

INDEX

A	F
Application request 79, 82 Artist-agent agreement 30, 43 Artist-gallery agreement 29, 34 Artist-gallery consignment agreement 29, 37 Artwork out 49, 53	Fax cover sheet 11, 18 Financial statement 19, 22 Five-year goals 65, 68 For the week of 11, 14 Form VA 29, 47 - 48
В	Н
Balance sheet 19, 27 Bill of sale 93, 98 Bookkeeping forms 19 - 28	Historical documentation of originals 49, 51 Historical documentation of prints 49, 52
C	Income/expenses 19, 20
Certificate of authenticity 93, 97 Certificate of title 93, 96 Check reconciliation form 19, 28 Checklist for a juried show 65, 77 Checklist for contracts 29, 31 Commission agreement 30, 41 Competition record 49, 56 Confirmation of exhibit 79, 90 Confirmation of sale 79, 89 Consignment schedule 29, 36 Customer forms 59 - 64 Customer profile 59, 61 Customer/client record 59, 62	Introduction letter 79, 80 Inventory forms 49 - 58 Item request record 49, 58 L Legal forms 29 - 48 M Mailing list sign-up sheet 59, 64 Marketing plan 65, 67 Marketing plans forms 65 - 78 Master inventory 49, 50 Memo 11, 17 Model release 30, 39 Monthly income by source 19, 21
Daily mileage report 19, 24 Daily organizer 11, 12	Monthly project status 65, 72
Daily planning schedule 11, 13	Office forms 11 - 18
Entertainment/meal documentation 19, 23 Exhibit expense planner 65, 75 Exhibition agreement 29, 33 Exhibitions/competitions 49, 57	

P

Phone-zone sheet 59, 63
Press release 79, 92
Price list 93, 100
Pricing worksheet for originals 93, 94
Pricing worksheet for prints 93, 95
Print planning calendar 65, 78
Project planner 65, 70
Project progress chart 65, 71
Projected budget 19, 26
Property release 30, 40
Provenance 93, 99
Publicity planning chart 65, 76

Q

Query to art publisher 79, 86 Query to book publisher 79, 85 Query to gallery 79, 81 Query to interior designer 79, 88 Query to magazine editor 79, 87

R

Rental-lease agreement 30, 42 Response to inquiry 79, 84

S

Sales agreement 29, 32
Sales forms 93 - 100
Sample issue request 79, 83
Sample letters 79 - 92
Sample marketing plan 65, 66
Show planning calendar 65, 73
Slide reference sheet 49, 54
Slides/photos/transparencies/portfolio out 49, 55

T

Target market chart 59, 60
Thank you for purchase letter 79, 91
Travel documentation 19, 25
Twelve-month goals 65, 69
Twelve-month planning calendar 11, 16
Twelve-month show planner 65, 74

W

Weekly schedule 11, 15 Work agreement 30, 38 Worksheets for Form VA 45 - 46

Art Marketing 101 A Handbook for Fine Artists

Get a jump-start on your career. Learn how to gain exposure and earn more money as an artist. Read about myths many artists fall prey to and how to avoid them. Identify roadblocks to success. This 336-page, 24-chapter, comprehensive volume covers all the key issues any artist needs to know to do business in the 90s. It includes:

Preparing a portfolio · Pricing your artwork

Secrets of successful artists

Alternative avenues for selling your art

Publishing and licensing your artwork

Creating client lists · Taking care of legal matters

Developing a marketing plan · Publicity tips

Succeeding without a rep · How to contact a gallery

Art Marketing 101 helps you take care of your business, with tips on everything from making winning portfolios to cultivating clients and selling at shows. Learn about the publishing, greeting card and licensing industries—something no other art marketing book explains. The book treats such topics as:

- → Must I depend on dealers, curators and gallery owners—or can I do it on my own?
- → How do I protect my work from plagiarism?
- → Case histories and artist success stories
- → Recommended reading for further studies
- → Checklists to help you stay on target
- → An "Action Plan" at the end of each chapter

\$24.95 Paperback \$29.95 Hardback

ArtSource Quarterly

Published every three months, this eight-page newsletter is packed full of new ideas that give fine artists the creative edge their art business needs, taking sales to new levels. Each issue covers a specific topic such as: publishing, pricing, the greeting card industry, grants, publicity, sales, taxes,

the licensing industry and more.

- · Interviews with successful artists
- · Articles by artworld professionals
 - · Innovative marketing ideas
 - · Hot tips and leads

8 issues (2 years) \$34

4 issues (1 year) \$19

ArtWorld Hotline

This four-page monthly newsletter has listings not found in any other publication—
the best opportunities to advance
your career. Listings include:

- · Consultants looking for artists
 - · Publishing opportunities
- · "Percentage for the Arts" commissions
 - · Gallery calls
 - · Residencies and grants
 - "Artist Beware" updates and more!

2-year subscription \$48.001-year subscription \$26.00

ArtNetwork Yellow Pages

If it's not listed here, you probably don't need it!

Save time and money with this carefully researched directory. A must for every artist's library, with over 2000 material and service listings for everyday business needs, including:

Art organizations · Art councils

Critics · Lawyers · Printers

Magazines · Reference books · Publications

Grant sources · Residencies · Retreats

Art Suppliers · Framers · Appraisers

Internet carriers

and many more!

\$12.95

Art Marketing Sourcebook

Locate sales contacts and target markets with this directory. Each of the 2000 specialty listings was obtained through extensive research and provides information on dealers' policies, target markets, review standards, commissions, names, addresses, telephone numbers, and other detailed information.

Reps · Consultants · Galleries · Art shows
Art publishers · Poster galleries
Specialty markets include:
African-American · Computer · Floral
Photography · Sculpture · Wildlife
and more!

\$23.95

In the competitive and fast-paced 90s, an artist needs to take marketing seriously. Here's a way to do it dynamically and economically! The *Encyclopedia of Living Artists* is a direct link to prime customers—including reps, consultants, gallery owners, art publishers and museum curators. These artworld professionals use this book to select artwork throughout the year for various projects. Artwork in the book is reproduced in high-quality full-color, along with artist's name, address and telephone number. Prospective buyers have direct contact with the artist of choice. All fine artists are invited to submit their work; no more than 200 artists are chosen for publication. Books take about one-and-a-half years to put together and come out in January of every even-numbered year.

ArtWorld Mailing Lists

130 corporate art consultants	\$40
140 print distributors	\$32
450 greeting card reps	\$50
175 calendar publishers	\$32
180 licensing companies	\$32
375 art publications	\$40
475 art organization newsletters	\$65
280 grants and residencies	\$32
325 book publishers	\$50
500 photo galleries	\$50
300 Canadian galleries	\$35
550 foreign galleries	. \$60
800 museum curators	\$75
530 museum gift store buyers	\$75
900 interior designers	\$75
1000 architects	\$85
900 art stores	\$75
1000 arts councils	\$85
780 corporations collecting art	\$95
1000 greeting card publishers	\$85
2000 art publishers	\$160
1900 university art departments	\$150
1900 university galleries	\$150
2400 art organizations	\$180
2400 frame and poster galleries	\$180
2600 reps, consultants, dealers	\$195
45,000 artists	\$90 per 1000
6000 galleries	\$85 per 1000

Mailing lists come on three-up pressure-sensitive labels and are rented for one-time use.

Counts and prices change constantly. Call to confirm.

ArtNetwork has gone on-line!

http://www.artmarketing.com

· You don't need to own a computer to visit our site.

A community college or library in your area probably has free access.

There is also an abundance of web cafes throughout the country where you can pay by the hour to access the net.

- Keep current on ArtNetwork's latest books, newsletters and mailing lists.
 - There are many art resources linked to our site.

Galleries, art suppliers, museums, newsgroups, art events, art publications, and many more helpful leads.

Each month brings new information.

· Find excerpts from our books and newsletters.

Surf into the chapters of our books and newsletters and find information and articles.

Artists' Home-Page

· You don't need a computer to show your work on-line.

We do all the advertising to bring corporate art buyers, art collectors, interior designers, reps, consultants, gallery owners and the general public to artmarketing.com.

In 1998 ArtNetwork will mail out over 100,000 postcards to artworld professionals informing them of our location on the Internet at artmarketing.com, encouraging them to visit our site.

• The cost to have a home-page is nominal.

Five pieces for one year, which includes all computer charges, along with 75 word bio and contact information is \$115, a half a year is only \$75.

Join us in the on-line revolution!

To sign up for Internet exposure, go onto the Internet and enter the "on-line ads" section. You can download all neceessary documents. If you're not connected to the Internet, call us at the number below and we'll send you a brochure explaining all the details.

Marketing Solutions by Sue Viders

Call for free marketing assistance at 800-999-7013 from 9-5 Monday-Friday (Rocky Mountain Time).

For a free *Image Evaluation*, send a color snapshot to the address below of the image you would like to have evaluated. Include a short note with specific questions and concerns. Enclose a SASE with 55¢ postage.

Use e-mail for a quick question, or if you live outside the continental United States.

Marketing Solutions
9739 Tall Grass Circle, Littleton, CO 80124
E-mail: viders@ix.netcom.com
800.999.7013

Marketing Solutions by Sue Viders

Books

Producing and Marketing Prints

A guide to getting started in the print market 81/2x11", 96 pages

Ten Steps to Marketing

Ten easy to follow steps 81/2x11", 68 pages

\$14.95

\$ 12.95

Art Charts

Hundreds of promotional ideas and checklists Tex 11x17" wall charts

Charts

\$19.95

\$ 9.95

Evaluation Chart

Determine if your work is marketable One 11x17" wall chart with mini-charts

Audio Tapes

Six Steps to Success

\$19.95

A comprehensive overview to art marketing 60-minute audio tape

Hints on Prints

\$19.95

Information on color, pricing and cover letters 75-minute audio tape

Marketing Solutions 9739 Tall Grass Circle, Littleton, CO 80124 E-mail: viders@ix.netcom.com 800.999.7013

ART OFFICE

On diskette

Make your life easier by getting this book on diskette.

You will need to have access to a Macintosh

with Pagemaker 5.0 or higher.

You can then print out directly from your computer all
the forms in this book.

It will be easy for you to scan and paste up logos or other clip art you want.

You will also be able to amend each form in any way you wish.

It couldn't be easier to get your files in order!

Clip out the bar code from the back of the book and send it along with

\$10 (plus \$3 shipping).

To order the diskette without proof of purchase (i.e. without the bar code cut from the back of this book), send \$14.95 (plus \$3 shipping).

To purchase both diskette and book, send \$24.95 (plus \$3 shipping).